SOUTH WEST WALES

Through the Lens of

HARRY SQUIBBS

VOLUME ONE

South Cardiganshire

PAM FUDGE

AMBERLEY

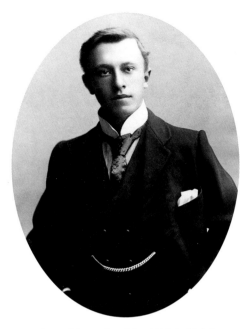

Fig.1: Harry Squibbs (1884–1946)
For my grandfather: artist, photographer,
entrepreneur, avid angler, and his
descendants.

First published 2014

Amberley Publishing
The Hill, Stroud
Gloucestershire, GL5 4EP

www.amberley-books.com

British Library Cataloguing in Publication Data.
A catalogue record for this book is available from the British Library.

ISBN 978 1 4456 3432 6 (print)
ISBN 978 1 4456 3438 8 (ebook)

Typesetting and Origination by Amberley Publishing.
Printed in the UK.

CONTENTS

PART 1
Harry Squibbs
His Life and Work as a
Photographer and Artist

An Introduction to Harry

This book is the first of two volumes. Together they provide a record of my grandfather, Harold (Harry) Edwin Squibbs' life and work as a photographer, producer of postcards and artist in South West Wales during the first half of the twentieth century. He was the second generation of a family of photographers and artists that spanned three generations. Although Harry used his given name (Harold) for business purposes, he hated it. He was always called Harry, so I have used his preferred name for these books, although postcard collectors will recognise his business name as Harold Squibbs.

This volume covers Harry's work in the communities along both the coast in South Cardiganshire and those inland along the northern side of the River Teifi. Included are some of the processes he (along with his father and his sons) used to produce the work he sold.

Volume Two will include his photographic and illustrated record of Pembrokeshire, largely in the northern part of the county and along the southern side of the River Teifi. However, he did range as far south as St Davids and Whitesands Bay, so examples of photographs of these areas are also included.

Although my book began as a single publication, I was encouraged by my publisher to produce a record of Harry's work in two volumes. This means that readers can access far more of the photographs he produced in the early 1900s. Splitting one book into two posed quite an interesting challenge as it separates two counties with very close ties. I suspect that if, like me, you were born on the banks of the River Teifi, you might have families who lived or still live in both Cardiganshire and Pembrokeshire and may see the river as a great link between the two counties rather than a boundary line. This was certainly the case when the two counties (along with Carmarthenshire) were part of one entity, Dyfed, from 1974 to 1996. This name dates back to the existence of the Kingdom of Dyfed in the fifth century. For some of my readers with interests across both counties, you may find you would like both volumes.

Part 1 of this volume includes biographical aspects of Harry's life, his family and work as a photographer and artist. His photographic record illustrates his view of the countryside around his home at a time when photography was going through great changes in terms of methods of production. Included are descriptions of some of the processes Harry used to produce the photographs, postcards and artwork he sold. He had learned most of these

techniques from his parents and added new photographic processes as they arose. Harry continued the family tradition by passing on his skills to the next generation.

At the end of this section is a selection of Harry's postcards showing the varying styles he used throughout the years he worked, together with information to aid dating his work.

Part 2 contains Harry's photographic record of his local communities and the events and activities that took place there. These are accompanied by historical and anecdotal information about life at that time, based on my memory of local lore and what I learned from my parents. The very high quality of Harry's work has enabled me to magnify parts of some of the photographs and include these as insets within the originals. This provides opportunities to look for and possibly recognise family members or family friends from the past. I would love to hear from you if you do recognise anyone in the photographs or if you have any more information about the events and historical information related to the photographs in the book. Do tell me if I've got anything wrong.

I have tried to avoid repetition in the biographical aspects included in part 1 in both volumes. However, some is inevitable. For those of you who have read both books, I trust that you will be patient.

Producing the Book

The initial idea for a book about Harry's work began while sorting out the things I had inherited from him. Retirement offers an amazing amount of time to do things that weren't possible while working, and this task offered great entertainment value. My collection includes Harry's sketches, paintings, etchings, an enormous number of photographs and postcards and a draft of entertaining short stories about his experiences in 'The Other Side of Fishing'. My intention was to start with the short stories, as they were an unexpected find and provided an interesting and exciting insight into my grandfather's life as a young artist and photographer. He certainly seemed to have enjoyed unusual extracurricular activities. So as I started to prepare them for publishing, I sought out Glen Johnson, our local historian and author living in St Dogmaels, for advice. He recognised the name Squibbs in relation to Harry's photographic work. When I explained that I had inherited his photographic collection of proofs, Glen suggested that this would provide valuable historical content for a book capturing South West Wales in the early 1900s. My focus therefore changed and this became my first target. The book of short stories about 'The Other Side of Fishing' was put on hold (publication pending).

Like many of us who had to leave South Wales to find work, I also have a need to keep returning home as often as possible. Producing this book has given me an insight into the lives of my family in the half-century before I was born. I hope that my readers will enjoy looking back in time as I have.

Once the decision was made to work on this kind of book, I contacted my cousin, Rob Squibbs. Between us, we had inherited a complementary collection of our grandpa's

work. While I had the postcards that Harry used as proofs to catalogue his work and record number changes along with some negatives, Rob had inherited the main collection of negatives and glass plates. Between us, we had a very large collection of materials of historic value. To produce the best quality photographs to include in the book, it was important to use the glass plates and negatives that Rob kindly lent me to work on. Unfortunately, our combined collection does not include Harry's complete postcard collection, as a significant number mysteriously disappeared when he passed away.

When I looked at the glass plates (231) and negatives (380) in two large cardboard boxes, I realised that this was going to take far longer than I had anticipated. They were stored in paper wallets, mainly 'Selo Roll Film & Print Wallets' (*Fig. 2*) distributed by Ilford Limited, London, in the early 1900s. Fig. 2 demonstrates one of Harry's recording systems. On most of the wallets, he recorded numbers attributed to the particular glass plates or negatives enclosed. I presume that these changes indicated that a new capture of the scene was available: a photograph may have been changed from glossy to matte; titles may have been altered or margins removed. The remaining

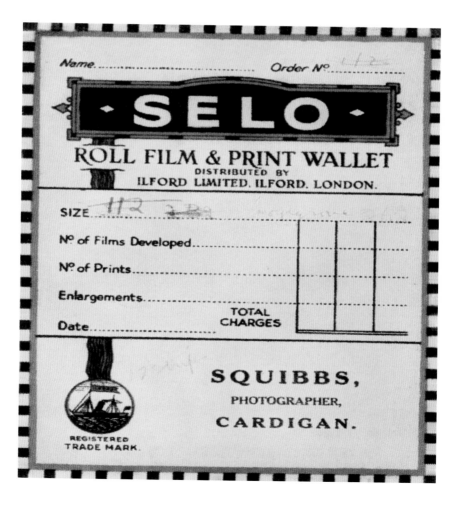

Fig. 2.

Figs 3 (*above left*) and 4 (*above right*).

plates and negatives were stored in the Kodak Wallets shown in Figs 3 and 4. Despite this seemingly straightforward storing system, the task was not easy as some of the negatives and glass plates had been stored in the wrong sleeve.

Each of the glass plates varied in size between 2¾ inches by 6⁸/₁₀ inches (7 x 17.2 cm) and 4⁶/₁₀ inches by 6½ inches (11.8 x 16.4 cm). Many appeared to be hand-cut while others were machine-cut. A few were stored in a box labelled 'Gevaert Dry Plates Anti-Halo Manufactured at Gevaert Factories VIEUX-SIEU, Antwerp, Belgium'.

The quality of the glass plates varied. Some were damaged: cracked, chipped and blemished. A few were in pieces requiring assembly like a jigsaw puzzle. Each one was scanned at 600 dpi (dots per inch) in order to retain all details. Once this was done, editing of both the plates and negative was limited to removing visible cracks, scratches and blemishes. It was important to retain the original appearance as far as possible so that the developed photographs looked as they would have when Harry produced them. I hope that if Harry were around now he would approve of the results.

The Squibbs Family and Harry's Early Life

Harry's parents, Abraham and Elizabeth Squibbs, were both artists and photographers. Abraham had trained as an artist at the Royal Academy in London. While there, he became interested in the connection between art and photography that began in the 1800s. It was the era when developing photographic techniques began to rise into the realm of fine art.

Photography was certainly a way of earning more money on top of his earnings from his work as an artist. His diary of 1871 showed that he continued his studies in fine art, with many visits to the National Portrait Gallery, but he increasingly acquired commissions to provide portraits for wealthy families. These opportunities appear to have come from a social, as well tutor-student, relationship with Mr George Scharf, who was Secretary and Keeper of the National Portrait Gallery. I was quite surprised at the amount Abraham was paid for some of the portraits he sold. For example, he was paid an impressive fee of £6 6s 0d for a portrait he sold to Col. George Arthur French, who was then sent to Canada as a military inspector. It would certainly have been useful to him as this was the year he married Miss Elizabeth Watts in London. They later returned to Abraham's home town in Bridgewater, Somerset, where Abraham set up their photographic and artistic business. Harry and his older brother, Arthur, grew up in this setting. Both were trained as artists and photographers at a very early age.

The two brothers had always had a very close relationship, which, I believe, became stronger when their mother died in 1895. Harry was about twelve years old and Arthur, who was ten years older, took on a caring role until his brother's education was complete. He also ensured that Harry trained as a draughtsman.

Harry's Progress in the World of Work

By the time Harry reached sixteen, he seems to have been living the life of a journeyman, travelling around the UK with his camera and equipment searching for photographic work, scenes to sketch, paint and photograph and, of course, places to fish. I can only presume this was a Victorian equivalent of a 'gap year' taken these days by many young people before making a decision about their future. His description of his experiences in his short stories suggests that these years were a mixture of unusual fishing experiences, learning to live off the land and sea with very little money and getting to know the ways of poachers and tramps. I discovered that he had found his way to Gwbert-on-Sea, in Cardiganshire, on a fishing trip with friends sometime between 1899 and 1900. He told my dad that he had been determined to return as he had fallen in love with the place.

In 1901, Harry turned up in Kings Lynn in Norfolk, working as a photographer. I am not sure whether it was he or his brother Arthur who first came up with the idea of moving to South West Wales. It was in this year that Arthur, his wife Anne and their baby Harold moved to New Quay in Cardiganshire. Harry continued his travels and made frequent visits to his brother and sister-in-law. On a return visit to Bridgewater, he met his wife-to-be, Ada Lucilla Polly Baker. This is his amusing record of their meeting that I found in his notes:

One day I was sketching the river through the branches of a very old oak. Behind me and lower down the river, the still, smooth water spread out, forming a mirror of some grand old oak trees with branches reaching from bank to bank. High up in the trees some youths had attached a rope and were having great fun swinging across the water.

Presently, two young ladies joined them, then the laughter suddenly ceased. A heavy splash was followed by a cry for help. The distance from my easel to the swing I covered in good time. My effort at rescuing the young lady seemed to take ages, but by hanging on to her hair – the only way of avoiding her clutches – I eventually dragged her into shallow water and finally led her up the bank. A few years later I led her to the altar, without struggles, dragging or hair pulling. We still have the sketch (*see Fig. 5*).

By 1907, Harry had moved to Cardigan, found a home and joined forces with his brother to extend the Squibbs photographic businesses in the area. He was happy to be near the River Teifi, which flows out to the sea between Pembrokeshire and Cardiganshire. The area offered all he wished for: beautiful scenery, a coastline that was second to none, a river (that for him was the best 'salmon river' in the world) and people who were friendly and welcoming. I can definitely support Harry's view. Pembrokeshire and Cardiganshire are beautiful counties. If you haven't yet come this far west I can definitely recommend it.

In March 1908, Harry returned to Somerset, married his fiancée and they settled in West Wales. This was a fitting place to bring his new wife to start their life together. Ada was a young woman who had worked as a nurse in extremely difficult situations. She thrived on the challenge of her new home in a different, if not far away, country,

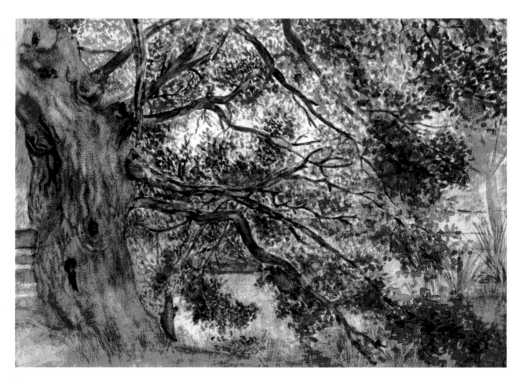

Fig. 5.

that she was so impressed with. This is where they lived for the rest of their lives and had their children, and where their grandchildren were born.

Harry began working from their first home in Park Avenue, overlooking the rugby field at the top of Cardigan. However, his aim was to get a property for his photographic business in the centre of town and, by around 1910, he had set up his first photographic studio in No. 51 St Mary Street. Although that is just off the High Street and near the centre of town, he wanted a more central location, and by 1914 he had moved to No. 38 High Street, Cardigan. His advertisements (*Figs 6 below and 7 overleaf*) provide an idea of some of Harry's ongoing work as a photographer at this time.

As was the case for most photographers, Harry's work covered the usual ongoing commitments, including weddings, portraits and events of local interest. These photographs often appeared in the *Tivyside Advertiser*, including annual photographs of the Mayor of Cardigan, those of events such as Coronation and Jubilee celebrations, carnivals, amateur dramatic productions, the rugby teams, properties for sale and school photographs.

In whatever spare time he could find, Harry continued to sketch and paint. This skill proved to be particularly useful in the production of portraits. As this was the time before colour photography got underway, commissioned hand-painted portraits were an important source of income. Harry had the skill required to produce excellent work. An example can be seen in the hand-painted portrait of his wife in Fig. 8 (*overleaf*) and in the miniature of his little daughter (*Fig. 11*) that can be seen on page 13.

Harry had already ventured into the production of postcards. It was this aspect that particularly interested him, possibly because he was always very much an 'outdoor man' and it gave him the opportunity to continue his wandering through the countryside. He saw this as yet another useful extension of his photographic business. Although both he and his brother had ventured into postcard production, it was Harry who really took this on board in an extensive and long-lasting way.

An additional aspect of Harry's photographic work came to light as I searched through my collection of family records and books. He produced photographs and illustrations for authors' books and guidebooks, including: *Key of All Wales* by Col. Sir John Lynn Thomas, who wrote the inscription in Fig. 9 inside the cover of

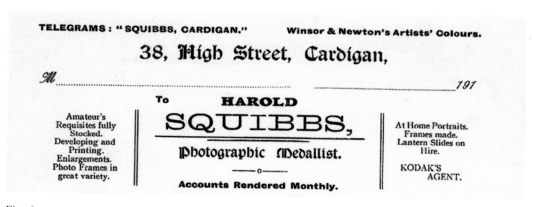

Fig. 6.

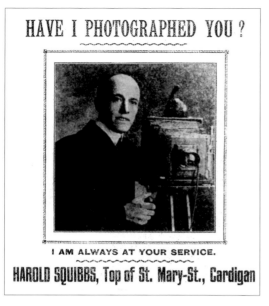

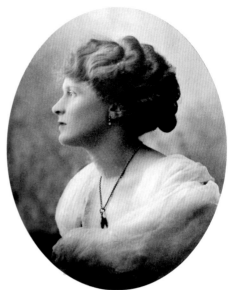

Figs 7 and 8.

Cardiganshire Antiquarian Society; *Transactions and Archaeological Record Vol. 2 No. 1*, Ed. Professor E. Tyrrell Green & D. Ernest Davies MA; *The Church Plate of Cardiganshire* by The Revd. John Thomas; *Cardigan ('Teify Side') The Official Guide*, issued under the auspices of the Cardigan Town Council. The photographs in these guides were commissioned by Raphael Tuck (*Fig. 10*).

In the meantime, Harry's brother, Arthur, had moved from New Quay to Tenby, where he set up his Squibbs Studio. They were both keen to expand their businesses across Pembrokeshire and Cardiganshire. Harry's first move was to set up a photographic arrangement with a gentleman in Newcastle Emlyn. I believe that this may have been a joint venture with a Mr E. Davies, who may have printed some of Harry's postcards. This lasted through most of the 1920s. I have only one of Harry's postcards and a few photographs taken in Newcastle Emlyn. Later, he set up a photographic studio in Fishguard, which operated through the 1930s and into the 1940s.

The year 1914 must have been a very difficult time for Harry and Ada as by then they had four little children: Eileen (five), Vivian (nearly three), Roy (one) and the youngest, Joan, who was just a few months old. There was an outbreak of diphtheria during that year, and in December Eileen (*Fig. 11*) succumbed to the disease. I believed that Harry produced this hand-painted miniature not long before his daughter died. Although my dad, Viv, was very young at the time, he always remembered his older sister as a funny and loving little girl.

An additional move then occurred to a more central position in town on the High Street in Cardigan. This was to Bank House – the tallest building in the centre of the sketch of the High Street in Fig. 12. I loved visiting there as a child and have happy

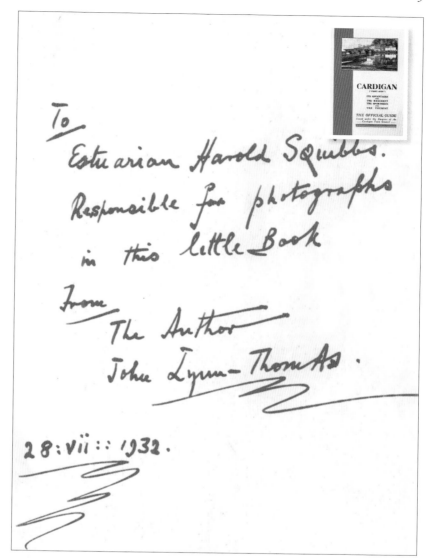

To

Estuarian Harold Squibbs.
Responsible for photographs
in this little Book

From
 The Author
 John Lynn-Thomas.

28: vii :: 1932.

Figs 9 and 10
(*inset*).

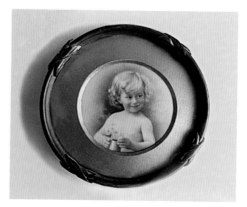

Fig. 11.

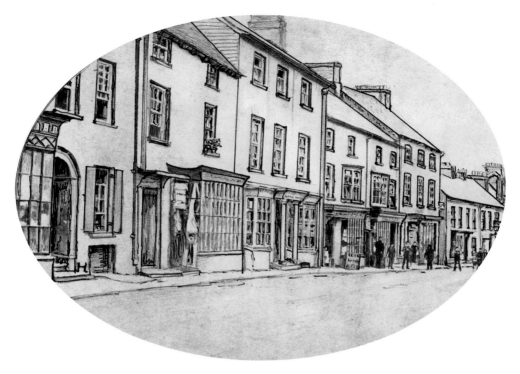

Fig. 12.

memories of Bank House as, when Dad came home from sea, we would go into the shop to visit Grandma. On either side of the entrance were two large windows full of all the goodies you could buy. We would walk up one step and through the two columns at the front of the shop. This was the part of the building where you were met with the smells of tobacco, sweets and artists' paints.

The room on the left was the place to go to buy artists' materials, fishing rods and wicker creels to carry the fish you caught – in fact, all the accessories you would need for fishing and catching the biggest salmon, bass or sewen (sea trout). This part of the shop was my favourite, as it also contained all of the paints, canvases, pencils, charcoals and sketch pads you could possibly need to produce your very own work of art.

Harry also sold cameras here. The one in Fig. 13 came from the shop and was a gift I received from Mr Cyril Burton. The other side of the shop was the place to go to buy sweets, tobacco, pipes and cigarettes or book a passage to New York.

At the back of the building was the photographic studio with the background screens painted by Harry, where people posed to have their photographs taken. Upstairs was the developing room, the living areas, kitchen and Grandma's classy café.

Harry, like many photographers at that time, diversified to include a large variety of products and methods of making money. To rely on photography alone for an income would have given the family very meagre earnings.

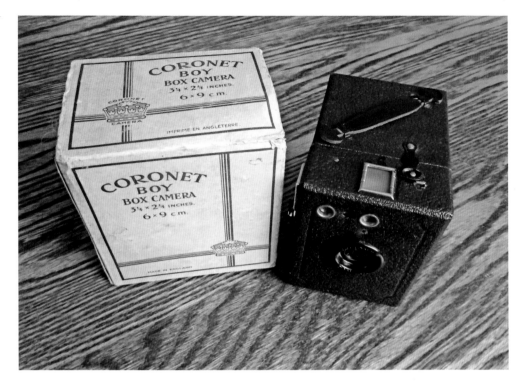

Fig. 13.

Harry's Versatile Artistic and Photographic Sales Activities

The greatest record of Harry's photographic work lies in the postcards he published and the photographs that remain. These were processed in a number of ways. Most of his general photographic work was produced in his darkroom as 'real photographs'. He started producing postcards around 1910. According to my dad, Harry used his etching of Cilgerran (*Fig. 14, overleaf*) to produce one of his first postcards. This may have been a one-off postcard as it is the only one of its kind in my collection and I haven't seen another like it that is postcard sized.

As was the case in producing his usual photographs, Harry's early postcards were also produced as 'real photographs' by developing his negatives and glass plates in his dark room. It was a labour-intensive process that did not lend itself to producing large numbers of postcards quickly. The results were silver gelatin prints, a method Harry would have been taught by his father, Abraham. The gelatin silver process was introduced in 1871 by Richard Leach Maddox. He found that if silver salts were mixed with gelatin to form an emulsion, this could be fixed on glass, paper or film and stored safely to be used to capture photographs and then processed later. It freed the photographer from the previous collodion wet-plate method that required

Fig. 14.

processing as soon as the photograph was taken. No longer would photographers need a cumbersome portable darkroom pulled around in a horse-drawn carriage. Abraham must have revelled in this development as it allowed him to take his camera and glass plates with him, take the photographs and develop them when he got back to his studio. This was the beginning of the photography we are used to, and by 1888 cameras that didn't need a tripod were available for amateur photographers to buy, followed by those like the Coronet Boy Camera sold by his son (*Fig.13*).

Fig. 15 is an example of Abraham Squibbs' work, the first photographer in the Squibbs family to produce a postcard. This photograph was taken sometime between the 1890s and 1912 when Abraham died. It is, I believe, quite rare and the reproduction of it in this book does not do it justice. It glistens and has great depth of tones. The copyright imprint on the reverse of the postcard (Squibbs & Carey) suggests that, although the photograph may have been taken much earlier, this print was published after Abraham joined forces with a Mr Carey in 1910. The company continued under the name Squibbs & Carey until 1929. The style of the print is very similar to one of Harry's produced around the same time (*c.* 1910). It is the second photograph included in the table in Fig. 22 (*see page 24*).

The event captured in the photograph is known as 'squibbing' and dates back to the Gunpowder Plot. This is an event that Harry, his father and brother would have watched each year. I was amused by the thought that a Squibbs photographed the 'squibbers'

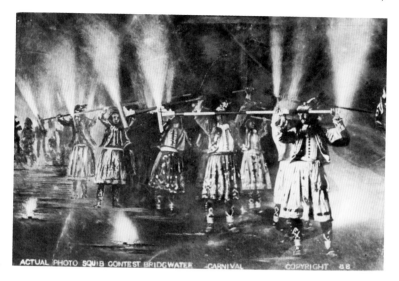

Fig. 15.

ACTUAL PHOTO SQUIB CONTEST BRIDGWATER CARNIVAL COPYRIGHT 88

in the photograph. The event takes place at the end of the Bridgwater Carnival on 5 November each year. Back in the 1600s, the West Country was mainly Protestant and celebrated the failure of the Gunpowder Plot in this way. The procession began with carrying homemade guys to the bonfire, and this later developed into carrying lit squibs. The squibbers were called 'Masqueraders' and, as in the year this photograph was taken, they dressed for the part. The squibber whose squib lasts the longest is the winner. The whole carnival with floats is quite spectacular and well worth seeing.

As Harry's postcards became popular, he probably found it less time-consuming to pay to have them printed. J. Clougher & Sons in Cardigan published some of his work, while some of his plates or negatives were used by national publishers, including Valentine & Son Ltd (Dundee and London) and Illingworth & Co. of London. Both Clougher and Valentine also added colour to some of Harry's postcards, as can be seen in Fig. 16 (*overleaf*). This one has Harry's copyright imprint on the reverse and is very similar in style to others printed for him by J. Clougher around 1915. These usually had the J. Clougher copyright imprint added along with the Cardigan coat of arms that appeared on the bottom right-hand side of the front of the postcards. I believe that this one was hand-painted by Harry before going for printing. He liked to control the finished product as much as possible. The style of colouring resembles his watercolour sketches.

During these early years, Harry used his love of etching as a way of reproducing more than one print at a time, therefore bringing in more income. Handling Harry's etchings reminded me of learning this straightforward process, which, for an artist, was a cost-effective way of producing a set of prints that can be sold as limited editions of their work.

Etching involves coating a metal plate with an 'etching ground' (a wax film). A metal needle-type instrument is used to draw the image required by cutting through the coating to the metal sheet. This is then dipped in acid that cuts into the exposed drawing on the sheet. The wax protects the areas not drawn on. When the wax ground

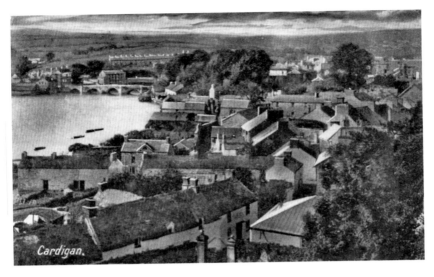

Fig. 16.

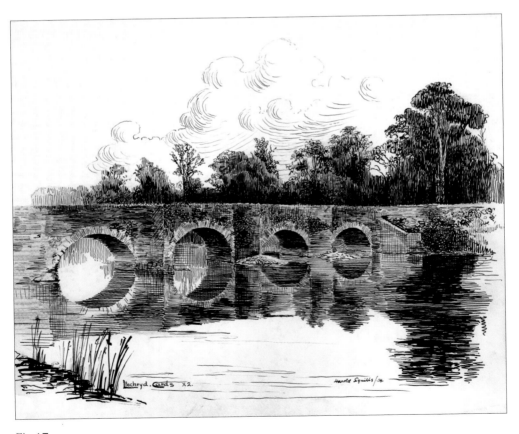

Fig.17.

is removed, the etched drawing is left. Ink is squeezed into the lines of the drawing that are cut into the metal sheet and the surplus is carefully wiped off. Then a damp paper is used to cover the sheet and it is placed in a press. When the print is removed from the metal plate, all that the artist has to do is sign and number it, as Harry did in his etching of Llechryd Bridge (*Fig. 17*). It would be interesting to know if any that he sold are still out there hanging on someone's wall.

Harry sold these etchings in his shop, along with reproductions and prints of the work of artists of the nineteenth and twentieth centuries. I still have some of the reproductions of landscapes and river scenes that Harry bought from Windsor and Newton Ltd. They were produced by a Swiss company, Vouga & Co. Editeurs, Geneva. The smaller prints by the artist F. Leteurtre and H. Barbier were approximately 13 inches x 7 inches, while the larger ones by L. Burleigh Brughl were almost poster-sized (20.6 inches x 13.8 inches).

Business Through the Generations and Photographic Practices

Embarking on this book brought back memories of how the business was very much a family affair. In those days, it was common to pass on skills to children so that they had job opportunities and ways of earning money in their adult lives. It was the same in my family. Harry, like his father, trained his four sons as photographers from a very early age, so that by the time they were teenagers they were familiar with the principles and practice of photography. It was only when I came across the negatives in Fig. 18 (*overleaf*) that I realised this practice had continued into my generation. Two of Harry's sons (my dad Viv and my Uncle Roy) attempted to continue the photographic tradition by passing on some trade skills to their daughters. My cousin Mary and I both had some lessons from our dads. Memory of my first lesson in portraiture came back to me with great pleasure and amusement.

It was an exciting day as Dad and Mum took me over to Bank House and into the studio with teddy in tow. Mum took the photographs of me while I took photographs of teddy and Dad gave us both instructions. I remember that afterwards I was shown how Dad developed the negatives, and I was so impressed with the magic of seeing the images appear. I still remember Dad asking me which of my photographs worked and why as we all looked at the results. I think that those early lessons really helped me with composition when I sketched or painted. Sadly, the photographs got lost, but I still have the negatives to remind me of the experience. I was surprised that I remembered parts of the conversation with lots of laughter but not feeling very happy about my teddy having to wear a dress.

Neither my cousin Mary nor I become professional photographers, although we did carry on Harry's love of art by starting our further education in art colleges. I still always carry a camera with me wherever I go.

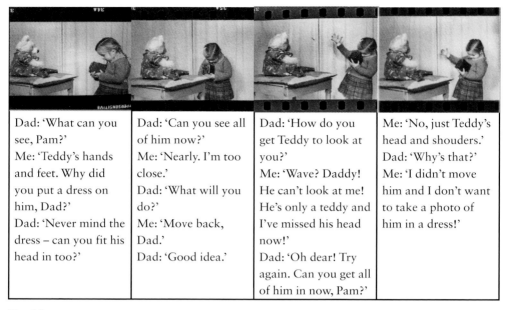

Dad: 'What can you see, Pam?' Me: 'Teddy's hands and feet. Why did you put a dress on him, Dad?' Dad: 'Never mind the dress – can you fit his head in too?'	Dad: 'Can you see all of him now?' Me: 'Nearly. I'm too close.' Dad: 'What will you do?' Me: 'Move back, Dad.' Dad: 'Good idea.'	Dad: 'How do you get Teddy to look at you?' Me: 'Wave? Daddy! He can't look at me! He's only a teddy and I've missed his head now!' Dad: 'Oh dear! Try again. Can you get all of him in now, Pam?'	Me: 'No, just Teddy's head and shouders.' Dad: 'Why's that?' Me: 'I didn't move him and I don't want to take a photo of him in a dress!'

Fig. 18.

An Annual Business Activity: Hand-Coloured Postcards

The practice of hand-colouring postcards continued after Harry's time. The main purpose was to use them to produce calendars each year. Production began just after Easter and involved deciding which postcards should be used for the coming year's calendars and how many would be produced for local communities.

The responsibility for Harry's routine was continued each year after he died – certainly well into the 1950s. All of the selected photographs were hand-painted. In order to ensure that they were available for sale from November onwards, everyone in the family who was able to do this sort of work was involved. Once coloured, the photographs were attached to mounts, as can be seen in Fig. 19, and little calendars were attached to the bottom. This was one of the calendars in the 1949 collection.

I was involved in this work at an early age when Dad thought my sketching and painting skills were good enough. He brought reject photographs for me to practice with. I remember him arriving home from Bank House in Cardigan on weekends with a box full of the mounts, postcards, calendars and glue. Mum would cover the dining table with an oil cloth and get out the photograph tinting box with tubes of oil paints, bottles of distilled turpentine and sizing fluid, brushes, matchsticks and cotton wool. Although watercolour, pastels or crayons could be used, Harry preferred to use oils that always appeared to me to be almost transparent, unlike the usual oil paints.

First, the photographs were prepared for painting. This involved rubbing each photograph with a few drops of the sizing fluid on cotton wool folded inside a piece of

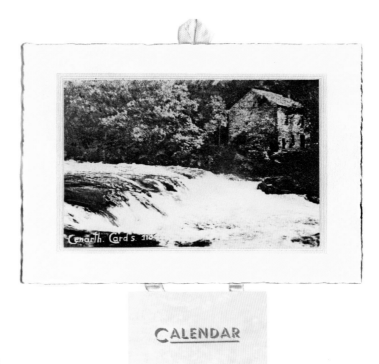

Fig. 19.

fine cotton. I don't remember how long it took to dry but it always seemed to take ages when I was keen to get started on mine. When the prints were dry, Mum and Dad would each take two or three photographs with similar scenes to work on. As they were mostly countryside scenes, many of the colours required were similar in each photograph. Mixing colours for trees with autumn colours, the river, sea or buildings could sometimes be applied across a couple of photographs at the same time. It was tricky as there was always the risk of smudging the work done and getting paint all over my sleeves, so for a long time I was restricted to one at a time. We each had an old plate for mixing our colours. The turpentine was used to thin the paints. The large areas, like the sky or sea, were worked on first using very small wads of cotton wool wrapped around matchsticks and then covered with tiny little pieces of silk or fine cotton. Mum would make these tiny brush substitutes in the winter. I preferred using the fine artists' brushes, which were essential when dealing with the areas needing minute areas of colour.

When this took place at home in St Dogmaels rather than in Bank House, finding space to lay the photographs out to dry was a problem. This took about twenty hours. As there was more space in my grandma's bedroom, this is where they were laid out on sheets of paper surrounded by a clothes horse to avoid any of us forgetting they were there and stepping on them.

The kit in Fig. 20 (*overleaf*) was my gift for helping with the calendar production. As you can see, I avoided using it and used Dad's instead, as I wanted mine to last a long time.

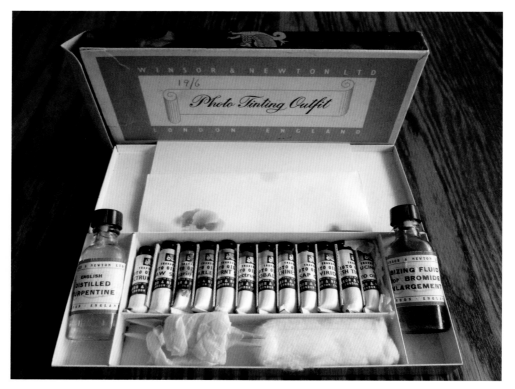

Fig. 20.

Harry Moves into the 1940s

The Second World War was a difficult time for all families. Harry and Ada's sons were in the forces: Viv and Roy were in the Navy and Arthur transferred from the Army to the Air Force in 1942. He was Squadron Leader 121396 in the 619 Squadron. What I think is unusual is that his father took the photograph (*Fig. 21*) of him in his Lancaster. You'll see Harry's blind stamp on the bottom left-hand side of the photograph. Harry was a very resourceful man.

Arthur's last flight in Lancaster LM 209 code PG-H was from Dunholme Lodge in Lincolnshire as a flight commander. The Lancasters on this raid headed for the Darmstadt area. They were under a great deal of flak and his plane, along with one other, was lost. The families of the crew were informed that they were missing. It was a long time before the plane was found. Any hope my family had of Arthur's survival was lost when they were informed that the crew survived the crash but had been murdered by the locals. Apparently, this was on Hitler's orders, as he described Allied Airmen as terrorists for bombing German cities.

It's hard not to think about the families of the other members of the crew who had flown together with Arthur on many flights like this one, so it's only fitting that they be mentioned. Arthur's crew were: Sgt James Davison from Northern Ireland; Warrant Officer Class 1 Lloyd George Evans of the Royal Canadian Air Force;

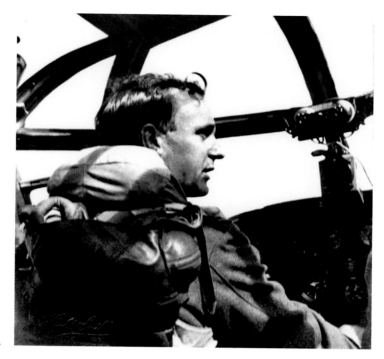

Fig. 21.

Sgt Albert Furnival, the Flight Engineer, from West Bromwich; Sgt David Greenley, the Air Gunner, from Anlaby, Yorkshire; Flying Officer James Francis Parry Air Bomer and Flt Sgt John Singer, the Navigator, from Aberdeen.

Harry passed away not long after, leaving Ada behind, who never really recovered from the loss of her son and her husband. On a brighter note, Harry left us wonderful visual memories of South West Wales, and I do hope you enjoy stepping back in time through his photographs in Part 2 with a visit to South Cardiganshire in the early 1900s. Perhaps you will be tempted to visit this wonderful area yourself.

Dating Harry's Postcards

In the following table is a glimpse into Harry's work and how it changed, with consideration of colour, finish (gloss or matte), margins, copyright imprints, titles and numbering. I have used Mr Peter Davies' system of dating Harry's postcards, along with access to postcard collections held by Mr Cyril Burton and Mr Glen Johnson for comparison.

Fig. 22: Harry's Changing Photographic Styles		
Appearance	Notes	Production & Mailing Dates
SQUIBBS, Photo. CARDIGAN.	One of a set of fifteen dark matt sepia postcards, with one margin at the bottom, including Regatta Day, The Netpool near Cardigan, Salmon Netting and this one of Cardigan church. In the margin is written 'Reg. by the Cliff Hotel', identifying who ordered the commission.	Produced *c.* 1910 and mailed 1910s/1920s.
Squibbs, Cardigan	Two imprints were used for this one: a blind stamp, 'Harold Squibbs' (front) and 'Squibbs, Cardigan' (reverse). Each of the imprints was used on real photographs with handwritten titles in capital letters and serial numbers. Also produced in black-and-white on glossy white paper. This one was used for in 1937 on Coronation Day.	This style was first used *c.* 1910s, mailed 1911–13 and later from 1937 onwards.
Squibbs, Copyright, Cardigan. Squibbs, Cardigan. Copyright	Black-and-white real photograph printed on very pale cream card gives a sepia appearance. Title and serial numbers in capital letters. The first of the imprints on the reverse is an early one. The second imprint was used later and with different styles.	Produced *c.* 1912–13 and mailed through the 1920s.

Appearance	Notes	Production & Mailing Dates
 Harold Squibbs, Cardigan	Glossy sepia real photograph. The caption is to the right in capitals and letter-press print with the simple imprint on the reverse. This photograph appeared in different styles, including one series with white margins and rounded corners to the photograph.	Produced *c.* 1910s and mailed through the 1920s/1930s.
 Harold Squibbs, Cardigan	One of Harry's rare hand-painted postcards with handwritten title on bottom left. Imprint on reverse.	Produced *c.* 1910–15.
 Squibbs, Cardigan	Real photographic postcard produced in sepia as well as in black-and-white. The upper-case letter-press title may indicate that he was commissioned to produce this series.	Produced *c.* 1912–20 and mailed *c.* 1912–32.
 FREE INFORMATION OF CARDIGAN & DISTRICT. Apply SQUIBBS, PHOTOGRAPHER, CARDIGAN.	Black-and-white real photograph with handwritten title and serial number on bottom right.	*c.* 1934–1940s.

Fig. 22: Harry's Changing Photographic Styles

Appearance	Notes	Production & Mailing Dates
	Black-and-white real photograph with handwritten title and serial number close to centre on the bottom.	*c.* 1935–1940s.
	First published as real photograph in sepia with curved corners against four margins, and later in black-and-white real photograph with handwritten title and serial number on the bottom right.	Produced *c.* 1911–13. Posted *c.* 1934–40.
	Black-and-white real photograph with handwritten title and serial number on the bottom right.	*c.* 1935–1940.
	Sepia real photograph with handwritten title prefaced with serial number on the bottom left.	1935–1940s.

PART 2
Communities in South Cardiganshire and North of the River Teifi in the Early 1900s

Aberporth

Aberporth was a busy port as far back as the 1500s. The northern beach was a safe place for ships to dock before heading for the port of Cardigan to unload or take on goods. Many of these came from Ireland with nets and salt to preserve goods. During the 1600s and 1700s, many of the people living in the area had work that was linked to the sea, and around the beach at the south of the town you would have found limekilns, warehouses and coal yards.

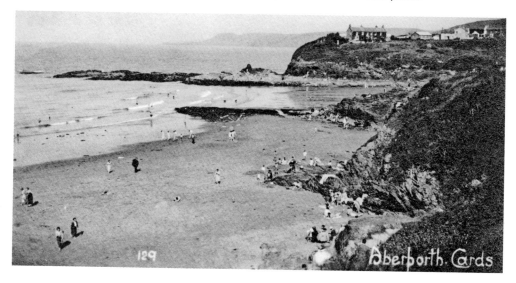

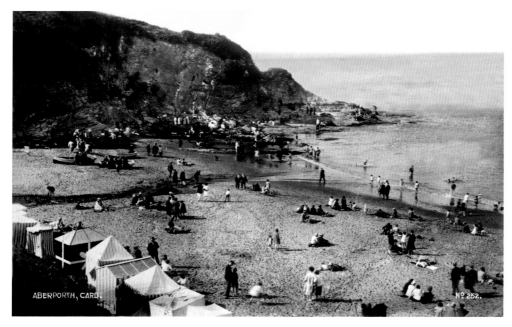

Aberporth became one of the major herring fishing ports in Wales, and remained so right up until just before the Second World War. At this time, fishing smacks like the one in the sketch (*inset*) were common on the seas around our coast in Cardigan Bay. I believe that around twenty of these smacks were net or drift fishing, and many were from here. Such activities stopped as fish stocks diminished and now fishing has been reduced to small-scale catches of crab and lobster.

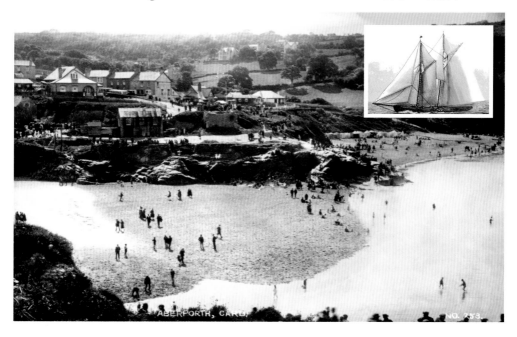

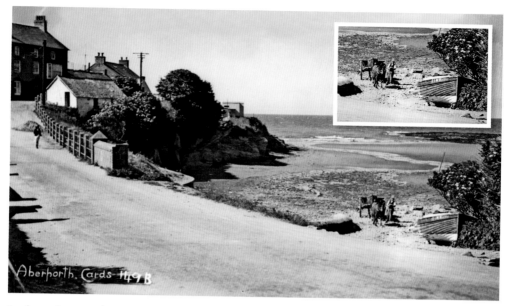

In those days, nothing was wasted, and the shore provided materials that could be used. This gentleman and his two horses (*above*) are bringing a cart load of, I believe, sand and mixed gravel off the beach to use for building.

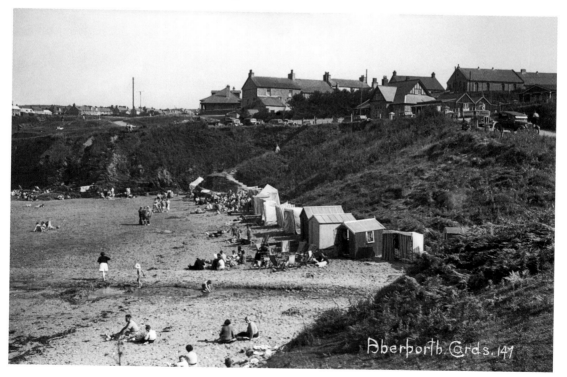

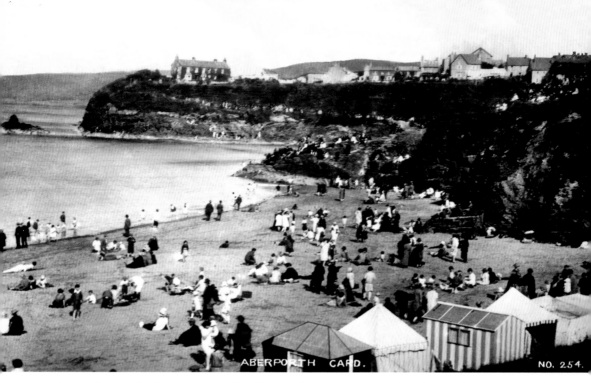

As can be seen in these photographs, Aberporth was a very popular place in the summer, with lots of activities going on. It still has its two beautiful beaches, wonderful walks, dolphins (if you're lucky enough to see one) and lots of watery experiences to enjoy.

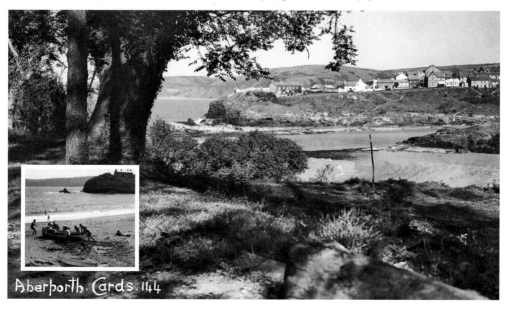

Cardigan

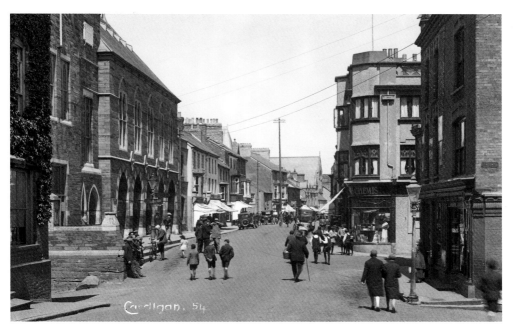

Harry included members of his family in quite a few of his postcards, as is the case in the photograph above. In the foreground are three of his sons (my dad, Vivian, and my uncles, Roy and Arthur) on their way back to Cardigan County School after lunch. Dating this photograph was thus made easier, confirming that it was taken around 1925/26.

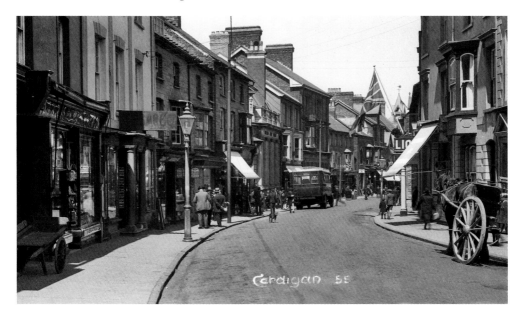

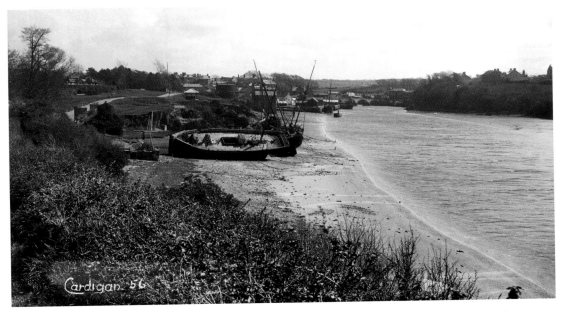

Cardigan is a coastal market town that, in the past, was an important port with a busy shipbuilding industry. The remnants of this can be seen in the photograph above. Trade came in and out of the town in large ships. The river and sea nearby, with its stock of shellfish, eels and fish, provided a livelihood for the locals, and it was not only fishermen but also fisherwomen who worked the Teifi (*below*).

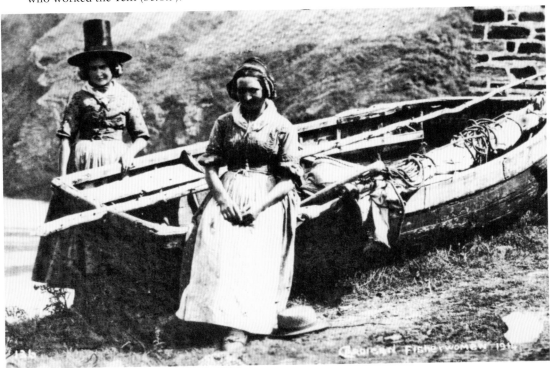

I was surprised to find this hand-painted photograph (*above*) in the family collection. It has a special significance for me, as the man watching the ship come in is my dad and this was one of the first postcards I had painted when I was about ten years old. It certainly wasn't good enough to add to the calendar collection. The photograph below shows Cardigan Hospital, which was once a priory.

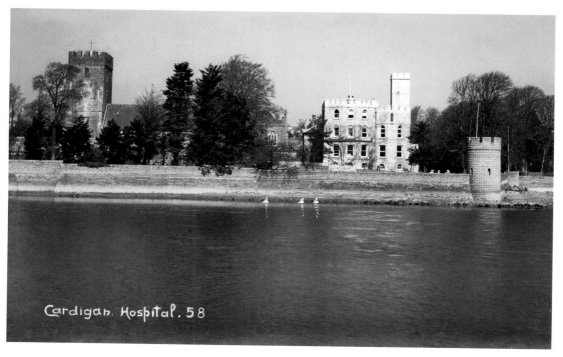

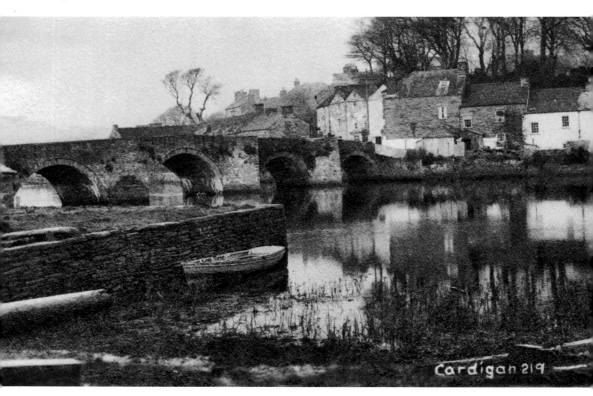

Cardigan was built alongside the river. Hidden behind the buildings and trees in the photograph above is Cardigan Castle, where the first eisteddfod is believed to have been held in 1176 by Lord Rees.

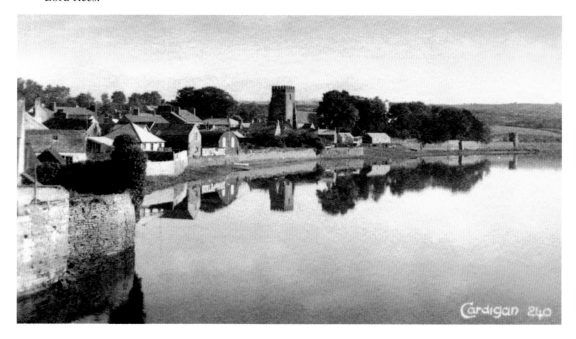

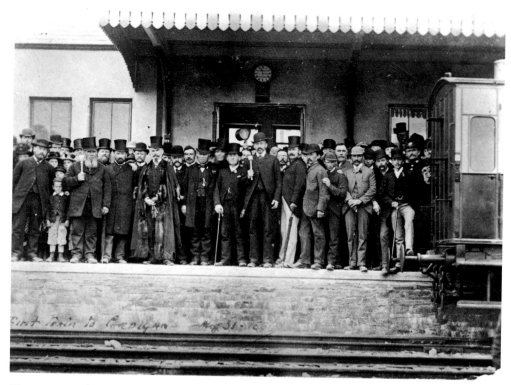

The opening of the railway was important for trade in Cardigan, as illustrated by the local turn out when the first train arrived in the photograph above. This was one of Harry's collection of old photographs. Part of the line from Whitland to Llanfyrnach was opened in 1873 to link with Glogue Slate Quarry, and a year later it was extended to Crymmych. In 1886, the extension to Cardigan was opened. The line and train, known locally as the Cardi Bach (Little Cardi), was an important link for communities and ran until Mr Beeching closed it in 1962, breaking all those well-established links.

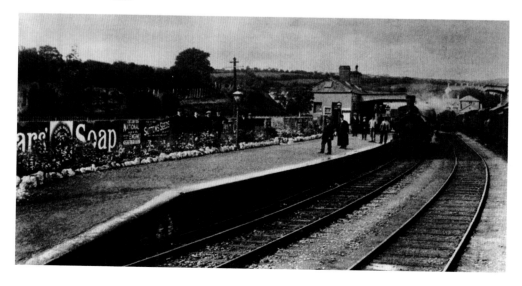

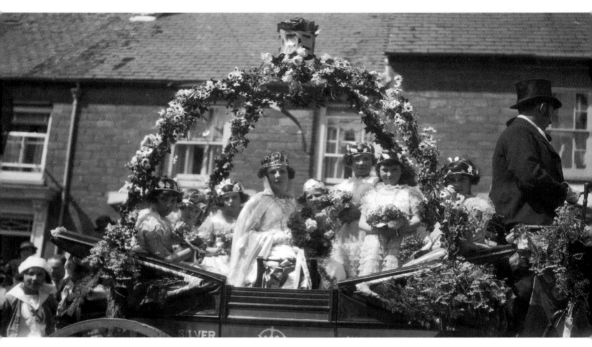

Cardigan celebrated the Silver Jubilee of King George in May 1935 with a carnival, carnival queen, attendants and an eisteddfod.

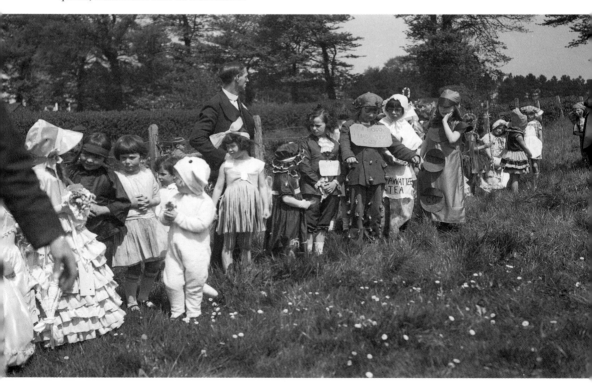

Who was this young man (*above*)? He obviously caught the attention of his audience. Miss Seaweed (*below left*) won first prize, though Miss Shipwreck (*below right*) must have been a close runner-up.

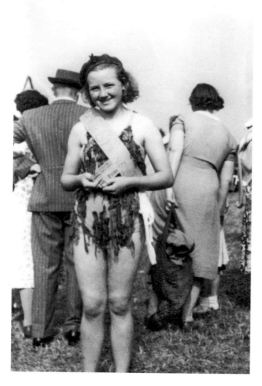

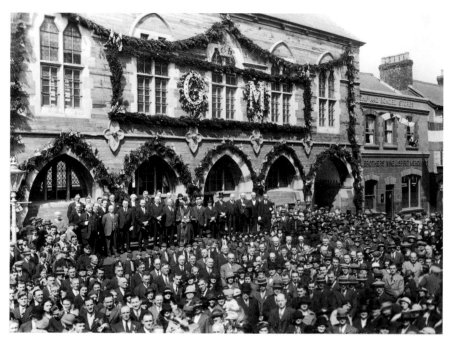

On 11 December 1936, King George V died, and all over the country people paid their respects. Harry had climbed up to the top of the shop and got everyone's attention for the photograph above. 12 May 1937 was the date planned for the Coronation of King Edward VIII, but he abdicated in December 1936 and it was decided that the same date would be used for the Coronation of King George VI. Cardigan organised celebrations with parades, parties, carnivals with floats and a huge bonfire.

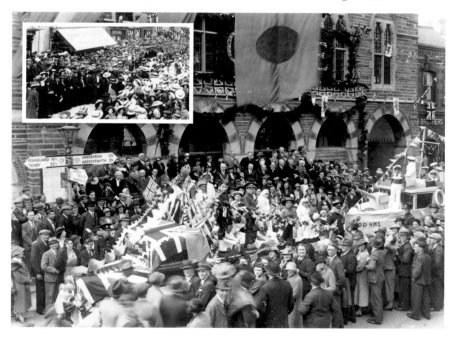

Cardigan ladies held a party, and the beacon is shown below, before and after it was set alight. Health and safety issues didn't apply in those days, although Dad did say that there was always someone sensible in charge.

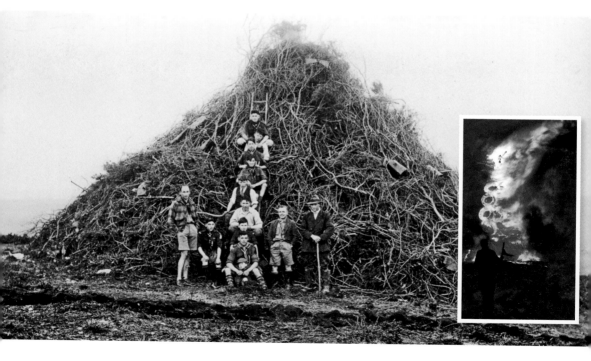

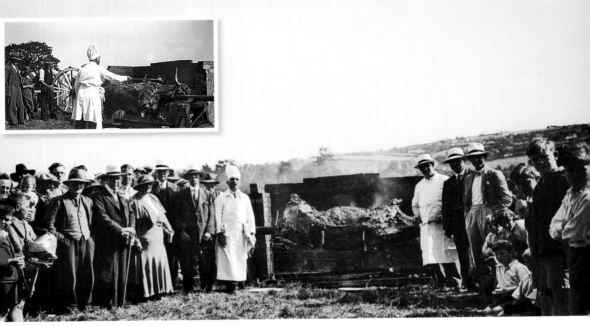

Above: This hog roast may have taken place as part of the 1937 Coronation celebrations. *Below:* On 30 June, the local Master Mariners had a reunion. The number of gentlemen in the photograph indicates the importance of shipping in the area.

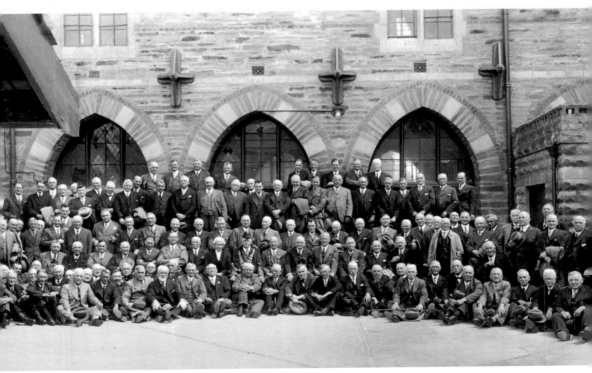

Harry was very interested in amateur dramatics, so I was not surprised to discover these two photographs. The one above is a production of *Nothing but the Truth* by the Cardigan Amateur Dramatics Group, *c.* 1936. Do you know what the one below was about?

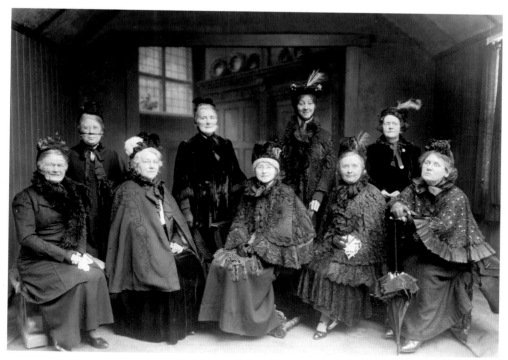

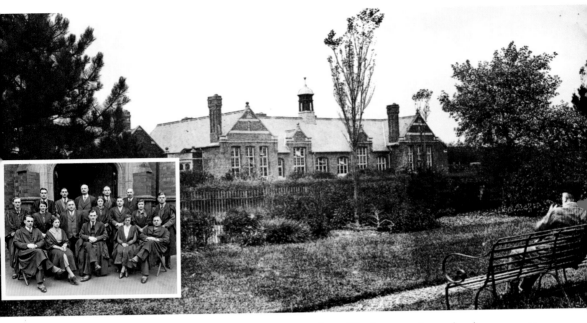

Above: This is Cardigan County School (Ysgol Sir Aberteifi), the secondary school my parents and I attended. Many of us will have very different memories of our experience here. In this photograph, you can see Mr Tom Evans, the head teacher, sitting on the seat contemplating his school. *Inset:* Here he is in the middle of the back row among the teachers back in 1935. In my time, we pupils called him 'Twm Pop'. In this photograph, he looks as severe as he did when I started secondary school there twenty-one years later. *Below:* It was pleasing to see the banner connecting Ysgol Sir (Cardigan County School) and Yr Urdd er Mwyn Cymru (Welsh League of Youth for Wales). As late as the 1930s, some schools in Wales were still punishing children for speaking Welsh in school by hanging the 'Welsh Not' (a piece of wood with WN carved on it) around their necks.

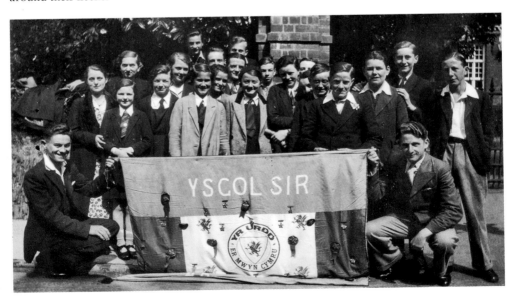

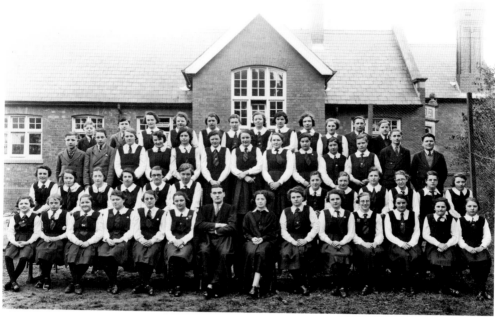

Lots of extra-curricular activities took place at the County School. The first broadcast from Cardigan was performed by the County School's choir in August 1933. The date on this postcard suggests that this may have been the same choir that performed in a musical festival held at the school in May 1935. Sport was also important. The photograph below shows the rugby team. Painted on the rugby ball is 'CCS 1st XV 1933–34', so this appears to have been taken at the end of the school year in 1934.

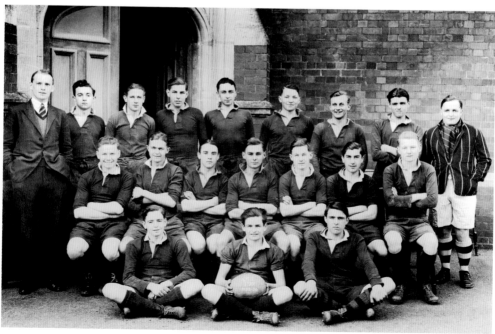

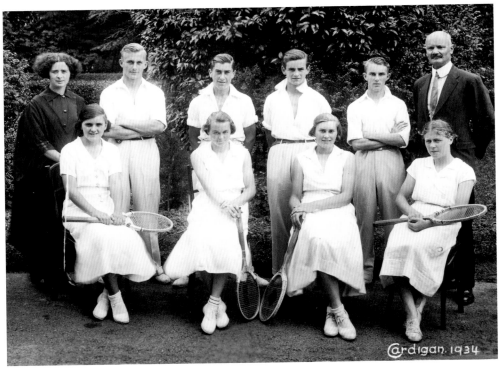

The 1934 tennis team is shown above, and below is a group of girls at the school, taken between 1934 and 1936.

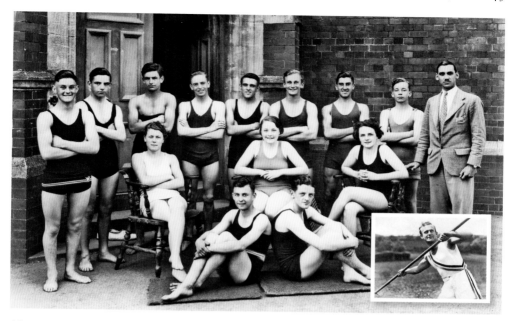

Above is a photograph of the school swimming team, *c. 1934–36*. It has been easy for me to pick out Harry's son Arthur in three photographs: those of the rugby, tennis and swimming teams (*see pages 41, 42 and above*). He also appears on the left in the back row of the photograph below. Perhaps this was a photograph of the head girls and boys. Harry must have felt proud of his son as he took these photographs. Arthur was an athletic young man who, according to the inscription on the back of this photograph, held the Welsh record for the javelin throw some time in the 1930s.

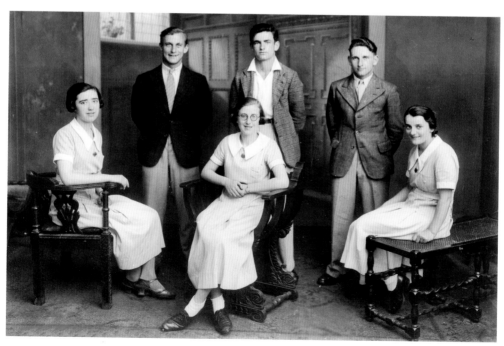

Cenarth

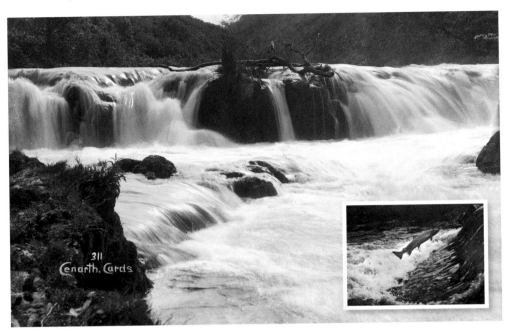

The River Teifi runs through Cenarth, tumbling over Cenarth Falls. It's a good spot to see salmon jump the falls to get to their spawning grounds. Harry spent many hours here in October and November after a very rainy spell. Then the river level would rise, making it a good time to try and catch them, both with line and camera.

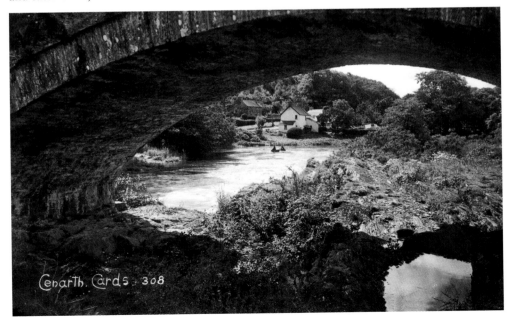

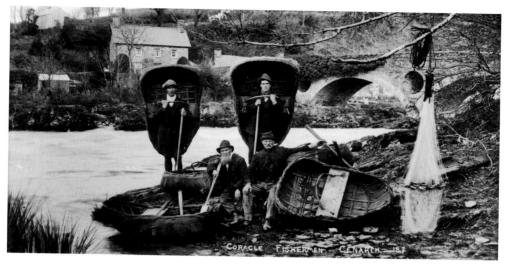

The coracle fishermen in the photograph are (back row, from left to right):
Mr David Morgan and Mr Jack Jones; (front row, from left to right): Mr
Richard Morgan and Mr Daniel Williams. Coracles are very versatile craft:
strong, able to get into the shallowest parts of the river (even over rapids)
and, as you can see, light enough to carry. The coracle fishermen are true
experts when they fish. They work in pairs, each holding the net between
the two coracles. When they know there is a fish in the net, they make sure it
remains there safely while carefully holding their end of the net in one hand
and gradually sculling closer to each other until their coracles touch and the
fish can be lifted into one of the boats. You have to be ambidextrous to do
this well. I will always remember the excitement of going up the river below
Cenarth in a coracle with my dad.

When in Cenarth a few years ago, I met Mr Denzil Davies. We talked about
his epic journey across the English Channel to France in 1973 in his coracle
– a journey that took him thirteen and a half hours. It's well worth reading
his book, *Mainly Cenarth*, which documents his story (D. Davies, 2010). I
believe he was demonstrating that similar craft used by the Mandan Indians
of North Dakota might have been developed from the idea of the Welsh
coracle introduced by Prince Madog in the twelfth century.

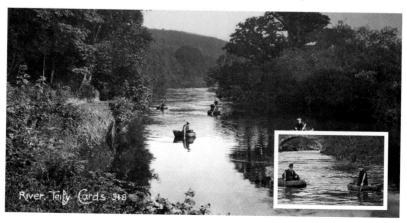

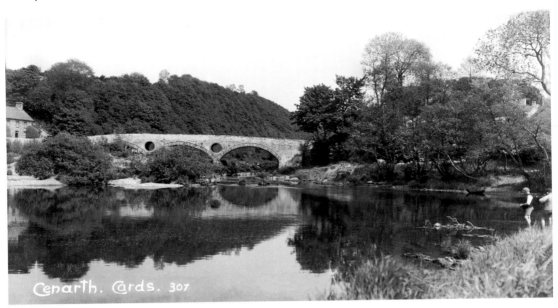

Cenarth is a very pretty place to visit. These photographs were taken downstream from the bridge. The one above was taken around 1920, as I can see two of Harry's sons, Roy and Viv, fishing on the right. Around ten years later, Harry recorded his family visit back in Cenarth with his son, Viv (in the coracle), and daughter, Joan, and her friend. They are all watching the coracle fishermen fishing. My dad, Viv, was pretty nifty in a coracle and loved fishing. I suspect he was picking up tips.

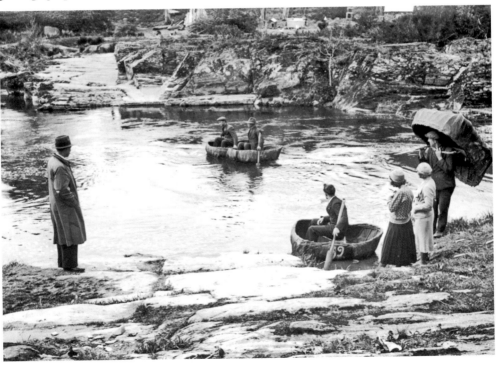

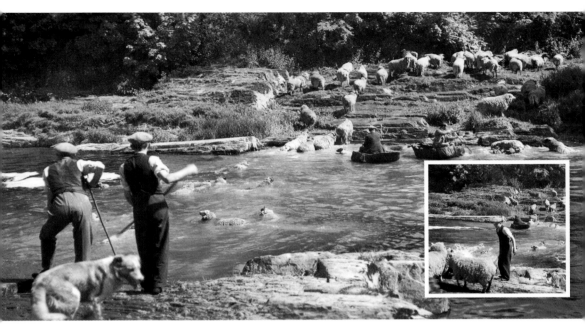

Sheep dipping was well worth watching in those days, as it took place in the river. This involved communal planning. Making sure that all the sheep made it safely across the river and none were swept away was crucial, so coracles were used as well as the sheep dogs. To protect the sheep from ticks, lice, blowflies and scab, they were first dipped in toxic chemicals, including arsenic, and then washed off in the river. Over the years, this has had a devastating effect on both the land and the creatures living in the river. Now things are monitored carefully in order to protect the land and reduce pollution in the river.

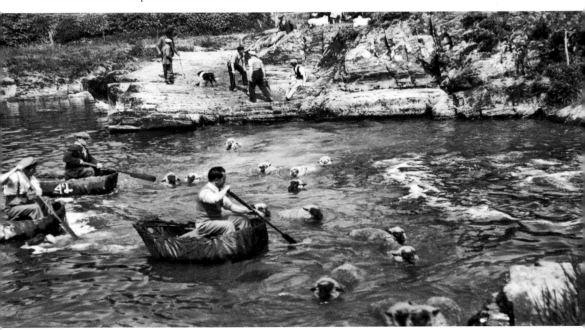

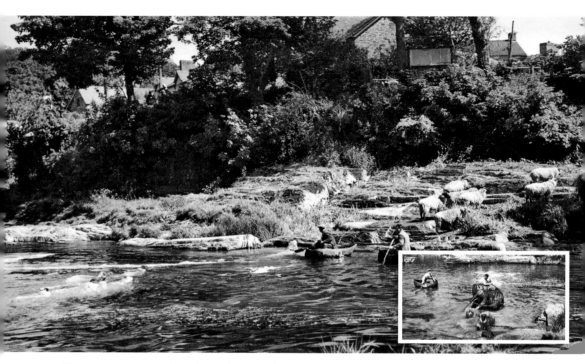

Harry got very wet taking these photographs. He started on one side of the river watching the sheep being persuaded to get in the river, and then he had to wade across in the middle of the process to catch the scene from the other side as they got to the other bank. Last sheep ashore! Time for everyone, even the sheep dog, to get out of the river and head for the pub. A job well done!

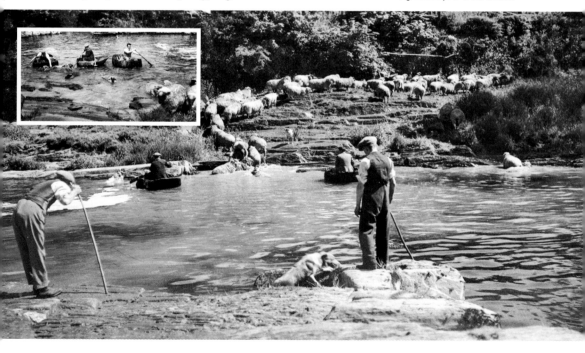

Cwmtydu

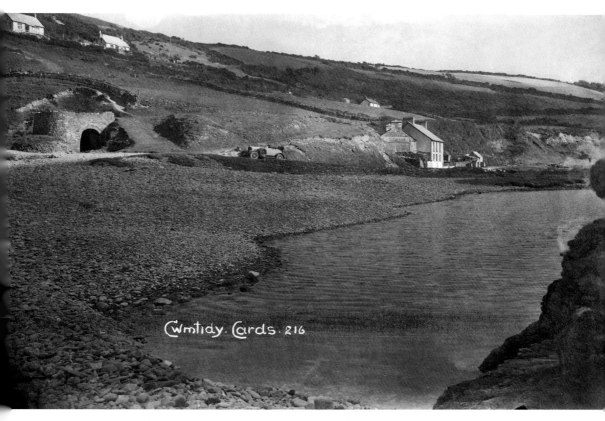

Cwmtidy. Cards. 216

Cwmtydu was a place I used to love visiting, but that didn't happen often as we had to wait for my dad to come home from sea and borrow Harry's car to get there. It was a great place as there was the limekiln and, of course, the caves to explore.

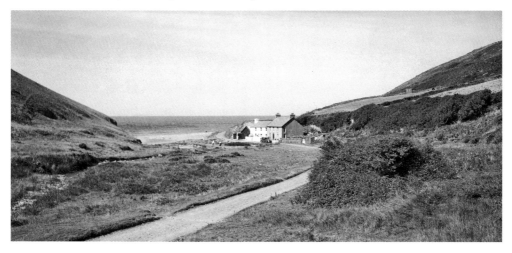

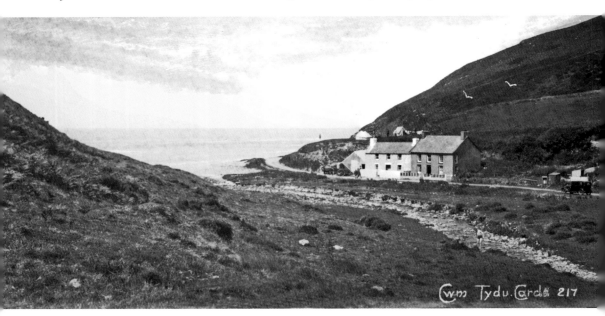

Dad used to tell me stories about the smugglers who brought their plunder here and hid it in the caves. I reckon this was a ploy to keep me happy digging for treasure. He also told me that, when he was about nine, a German submarine arrived at the beach. They had run out of water and the captain knew there was fresh water there as he'd been there for a holiday. As Dad was always making up stories, I just didn't believe him. After all, why would someone come all the way from Germany to Cwmtydu for a holiday? It's only recently that I've found he might have been right about the submarine.

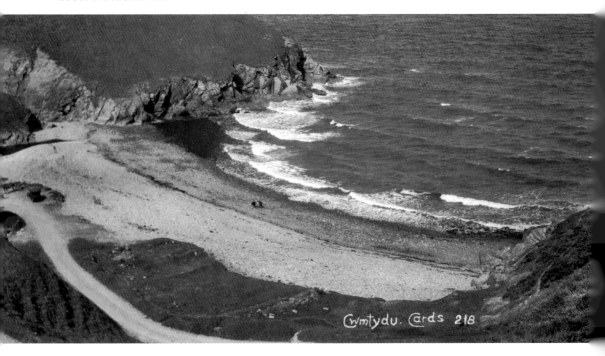

Gwbert-on-Sea

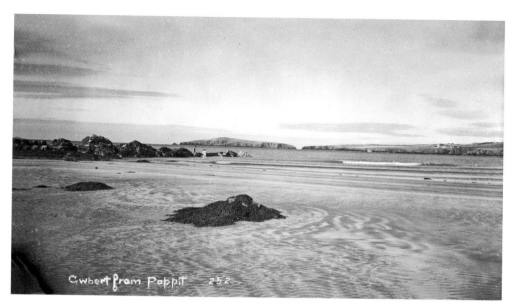

Gwbert from Poppit 252

Gwbert-on-Sea and Poppit Sands are found on either side of the estuary of the River Teifi. The view above of Cardigan Island and Gwbert-on-Sea from Poppit Sands is still one of my favourites. My childhood memories are of frequent family walks down to the beach, occasionally to fish but often to gather driftwood for the fire. In Victorian times, this was a popular place to take a walk, breathe in the fresh air, gaze out at the sea and, if you were inclined, to have a swim. Today, it's still as lovely as ever. Gwbert-on-Sea has interesting coves and caves to explore. The cove in the postcard below was Harry's favourite and he took his family there most Sundays with a picnic, come rain or shine. They would walk along the coast until they could see Cardigan Island and look for dolphins.

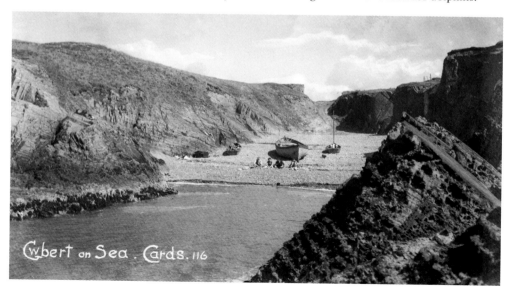

Gwbert on Sea. Cards. 116

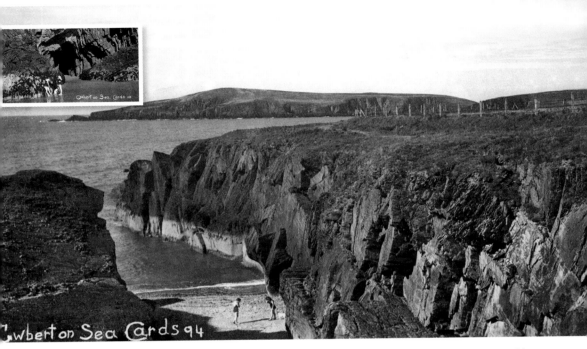

Gwbert on Sea Cards 94

Harry's bathing belles appear again in these photographs. They are his daughter Joan and her friend. It's an exciting place to go and there are a couple of good hotels to stay in. Things here have changed in terms of facilities but the special atmosphere is still the same.

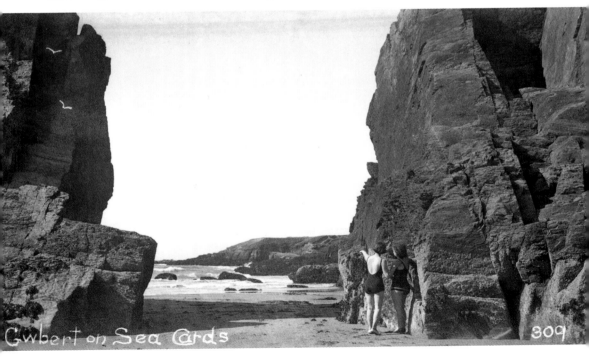

Gwbert on Sea Cards

309

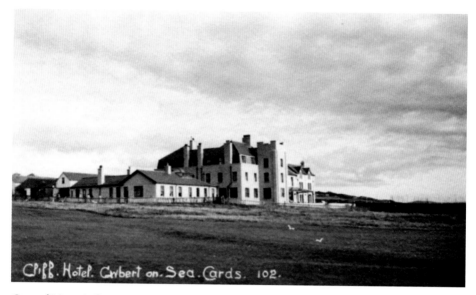

One of Harry's first commissions was to produce a set of postcards for the Cliff Hotel, which stands on the headland. It is still there and, along with the Gwbert Hotel, provides accommodation with amazing views over the Teifi Estuary and the sea. The view below shows the rocky coast and Cardigan Island.

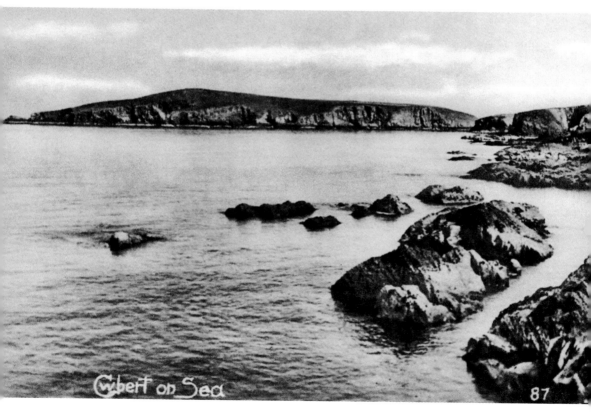

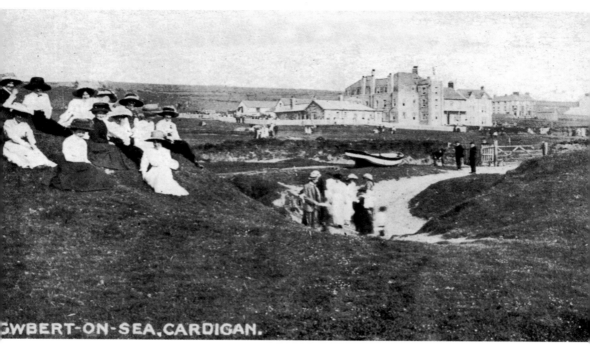

The photographic fashion of the time was formal and people were posed, as is the case in the photograph above. Harry much preferred to capture things as they were happening, as is the case in the photograph below. This appears to be an active day out for the ladies on the beach in Gwbert. The Cliff Hotel can be seen towards the left of the headland, with Cardigan Island in the background.

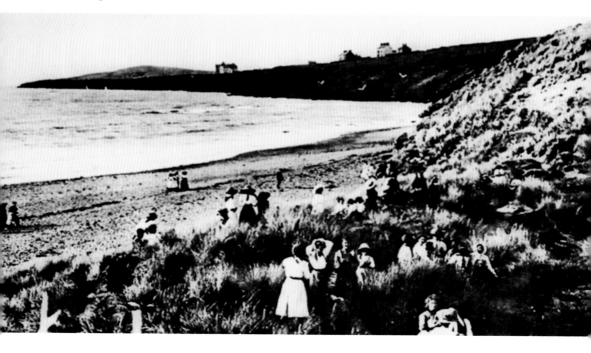

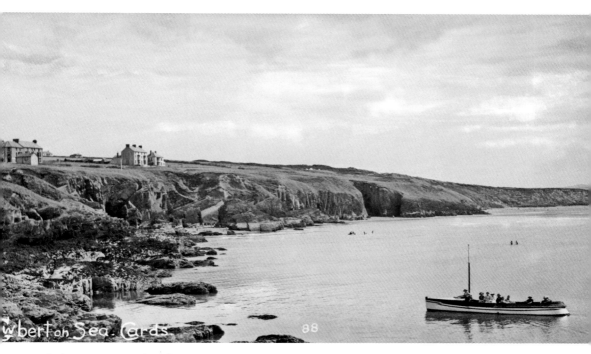

Gwbert was a popular place to go. Mr Tom Bowen took both holidaymakers and locals on boat rides around the bay and Cardigan Island as well as up and down the River Teifi. His boat was called the *Dancer*. In Harry's day, camping on the beach was a popular pastime.

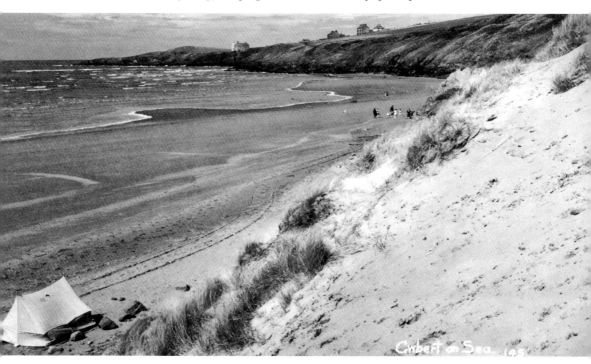

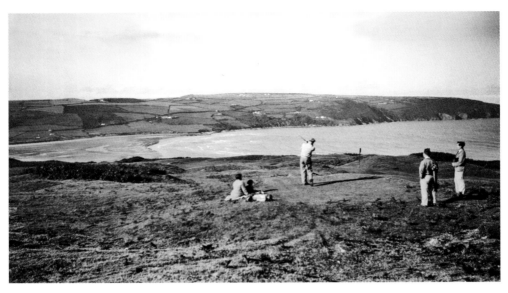

Cardigan golf course still provides the opportunity to play a round in superb scenery. The club was first called the Cardigan and Tivyside Golf Club and the first game was played there in 1895. The nine-hole course was difficult to maintain and fell into disrepair. A second attempt was made in 1902 by a Mr Arthur Clougher, who was the mayor of Cardigan at that time. Again, this didn't work out, but things really took off from 1910 onwards and Cardigan Golf Club was set up. It still operates today. The two men in the inset photograph below seem to be contemplating where the ball will land.

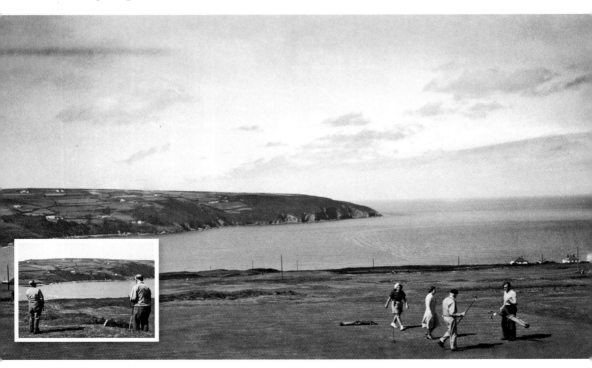

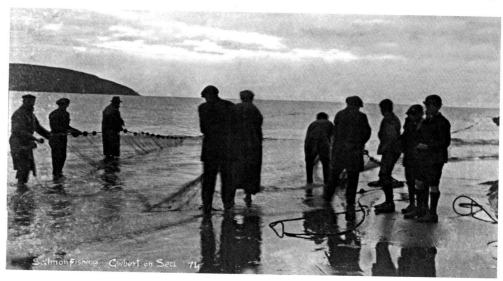

Fishermen have used seine nets to catch salmon and sewen along the River Teifi and at the estuary since seine net fishing was introduced by the monks in St Dogmaels Abbey back in 1118. It was always fun to watch them setting the nets and pull in the catch. In Harry's day, fish supplies were still sufficient to provide the fishermen with a meagre income. Even then, Harry was concerned that fish stocks were being greatly reduced, threatening the local fishing industry. He was right – once there were about 150 seine fishermen fishing the River Teifi between the sea and St Dogmaels. Only a few remain who are trying to keep the tradition going. Major difficulties were illustrated in an article in the *Tivyside Advertiser* on 31 August 2011. The pools used had not been dredged and had silted up or contained trees, which had washed down into them. None of the agencies appear to accept responsibility. The cost of a licence has increased and our heritage is threatened. In the photograph below, the fishermen have been successful and move on to the next pool to set the nets again. Hard work!

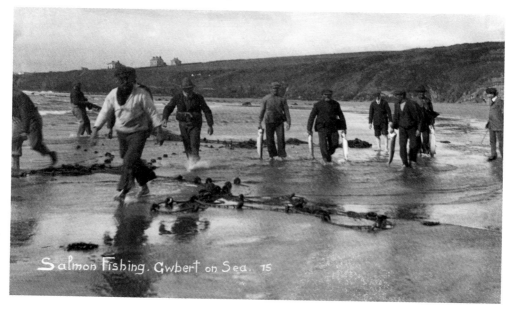

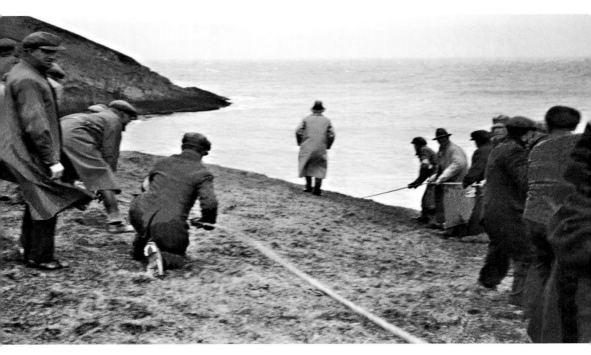

In March 1934, the SS *Herefordshire*, with a skeleton crew of four riggers (Robert McKenzie, who headed the team, John Walker, John Arthur and Robert Birt), was on a journey from Dartmouth to the Clyde for ship breaking. It was attached to two tugs: the *Chieftain* and the *Wrestler*. During the disastrous journey up the coast, the weather deteriorated to such an extent that it became difficult for the two tugs to manoeuvre the liner. First, the hawser attaching the *Herefordshire* to the *Wrestler* became detached. As they journeyed further up the Pembrokeshire coast, the weather became even worse, with winds reaching hurricane force and the waves becoming gigantic. As if this wasn't bad enough, the Herefordshire's crew next found they had become detached from the remaining tug, the *Chieftain*, and were adrift. The *Hereford* ploughed on up the coast, just missing hitting Cemaes Head, and was next heading straight for Cardigan Island, where the ship landed up wrecked on the seaward side.

As the liner began to tilt and break up, the crew realised that no rescue was possible and they had to leave the ship. They managed to get onto the island without loss of life. Then they had to scale the treacherous 200 feet of cliffs in the gale. Mr McKenzie reckoned that they wouldn't have managed this without their experience as riggers. When they got to the top of the island, they could see a rescue party on the mainland. Mr Tom Parry of the Gwbert Life Saving Crew fired a line attached to a rocket across the quarter mile of rough sea between the mainland and the island. Despite the gale that was still blowing, it was a super shot that flew straight over the heads of the crew, landing safely on the island.

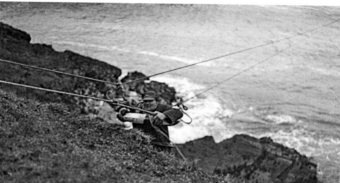

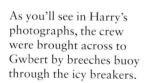

As you'll see in Harry's photographs, the crew were brought across to Gwbert by breeches buoy through the icy breakers.

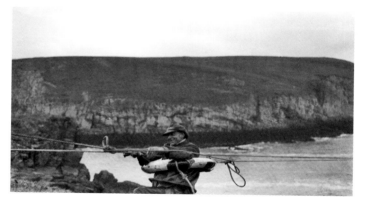

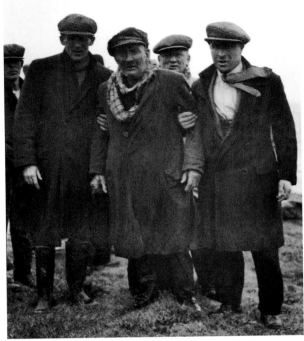

Hot cups of tea were provided by three ladies (Mrs Jenkins, and Misses M. E. and Megan Jenkins). This would have been appreciated by everyone on that cold stormy day. Mr McKenzie, who was the first to reach the mainland, said, 'That was the coldest quarter mile I can remember. It's after a trip like that that you appreciate a cup of tea … Man, it's the best drink I've had for years.' I found quite a lot of this information about the rescue in the 'Those were the Days' articles, written by Mr Donald Davies and published in the *Tivyside Advertiser* in 1984. I was hoping to be able to fit the names of the rescued to the photographs. Unfortunately, this was not to be as Harry left no notes and his negatives were not numbered or ordered in any way.

Henllan

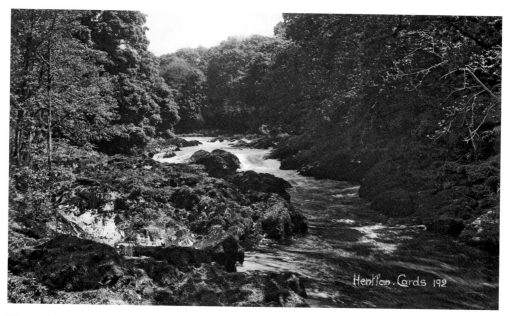

I have always thought that one of the prettiest parts of the River Teifi is where it passes Henllan. These photographs were taken *c.* 1923 as the boy in the lower image is my uncle, Roy, when he was about eleven years old. This was as far up the river as Harry went for his photographs. It's further upstream than Newcastle Emlyn.

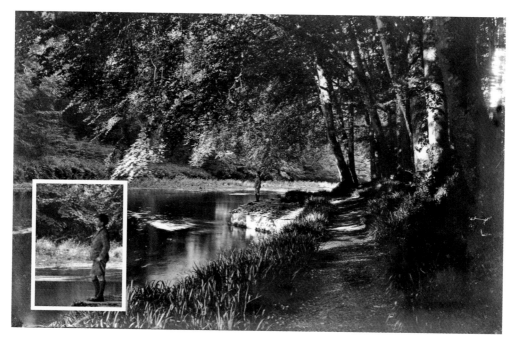

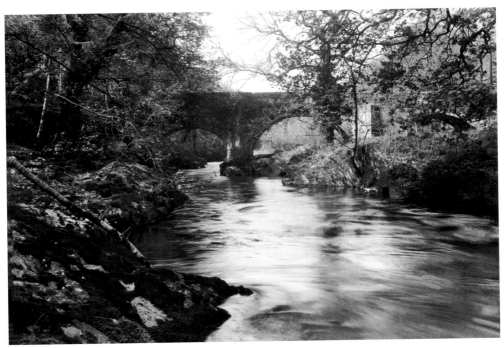

In addition to the river views and Ffrydiau Waterfall, Henllan also has an interesting triple-arched bridge that carries the old turnpike road. This ran from Newcastle Emlyn to Carmarthen and was written about in 1833 by Mr Samuel Lewis, the author of *A Topographical Dictionary of Wales*. You can certainly get a feeling of stepping back in time here.

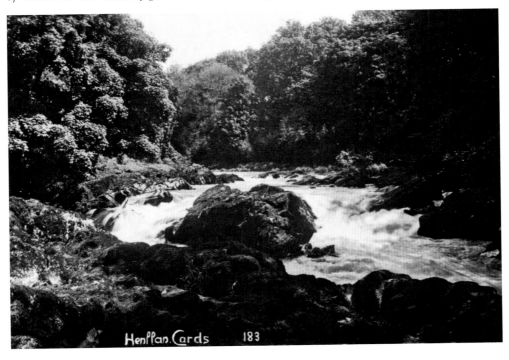

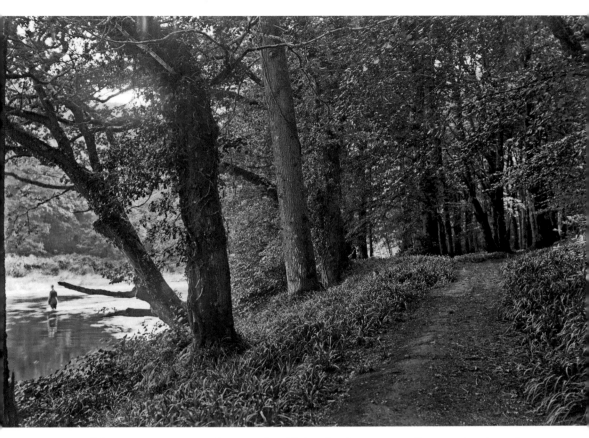

As you will have seen in Harry's photographs, this is a lovely area to walk around and see the River Teifi change character as it flows through the countryside. There are planned walks you can follow along the riverside (*see references for website*).

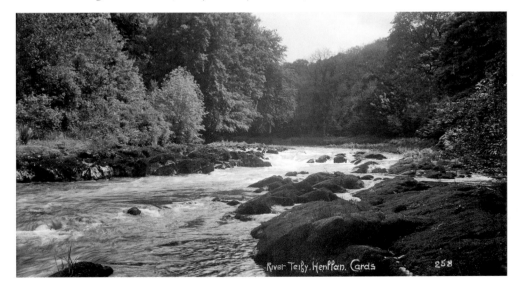

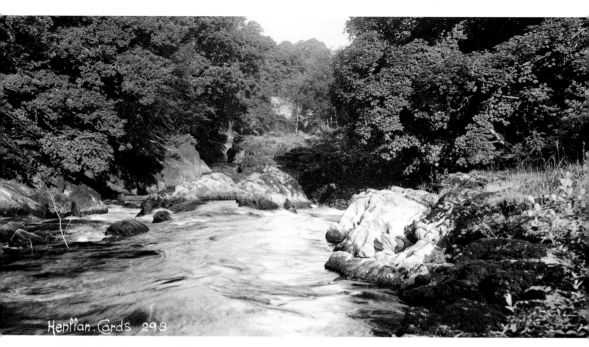

Following the River Teifi gives you the variety of seeing it thunder through turbulent rocky areas followed by parts where it calmly slips through wooded areas as a smooth flowing river. On a clear day, the reflections in the water offer a tranquil scene.

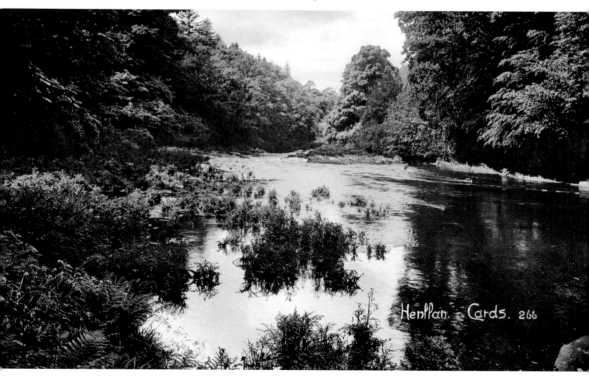

Llangranog

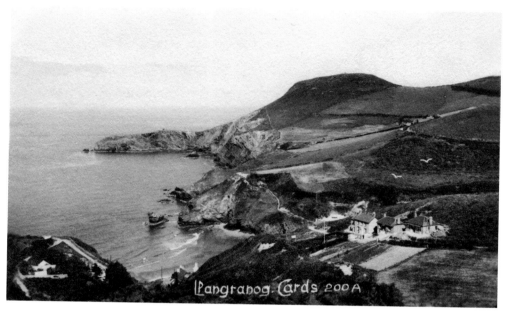

As was the case for many of the coastal hamlets, Llangranog thrived on herring fishing. About eight to ten smacks worked out of Llangranog in the early 1800s. These vessels were worked by twenty to thirty fishermen. Llangranog is still a lovely place to visit, just as it was in ancient times when pilgrims came to visit St Mary's Well, believing that the water was beneficial to health. The coastal walks that run along the coast both to the north and south of Llangranog offer wonderful views.

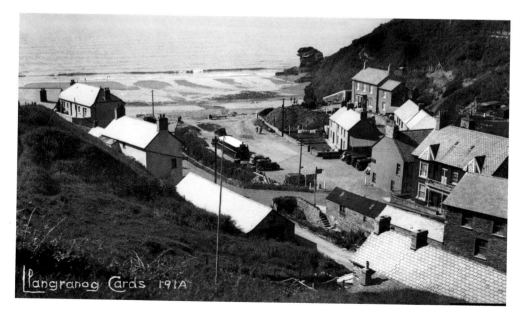

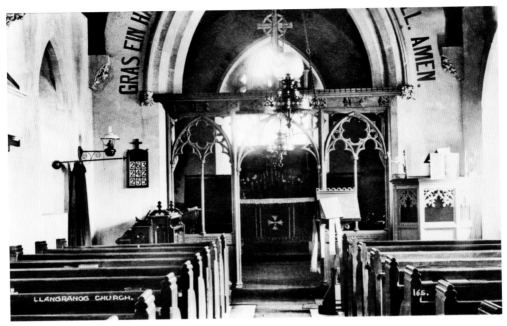

Llangranog is believed to have taken its name from a Saint Carantoc, who lived in the area around AD 500. The story goes that he spent a lot of time living a solitary life and praying. One day, when he was carving wood, a pigeon picked up one of the pieces he had dropped and flew off with it, eventually placing it down in the valley. Carantoc decided this was God's message and built the first wooden church there. The current St Cranog's church was built in 1884. It does have some rare features, like the seventeenth-century bell, a sixteenth-century silver chalice and a font that dates back to Norman times.

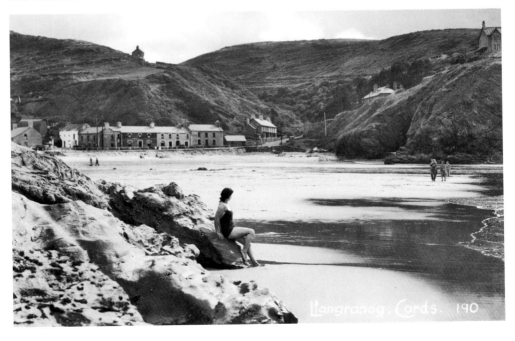

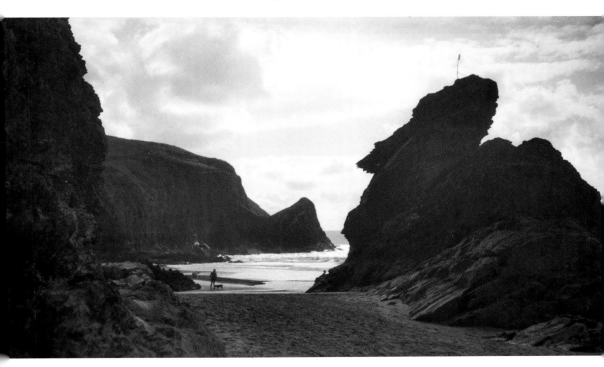

Strange-shaped weathered rock stacks lie around the coast. Like many, this one has a name: Carreg Bica (Bica's Rock). Legend has it that it is the tooth of the giant, Bica, who had such bad toothache that he spit the offending tooth out onto the beach.

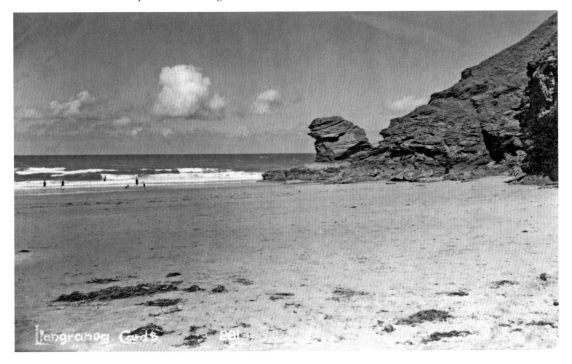

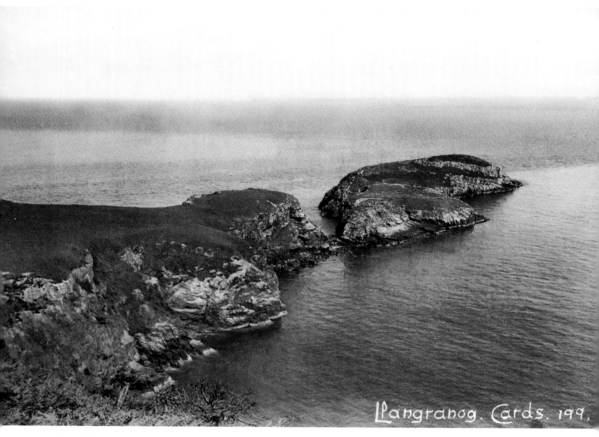

Llangranog. Cards. 199.

A walk up the coast takes you to Lochtyn Headland and island, where, on a clear day, you can see as far as the Welsh mountains. If you're lucky, you may even see dolphins.

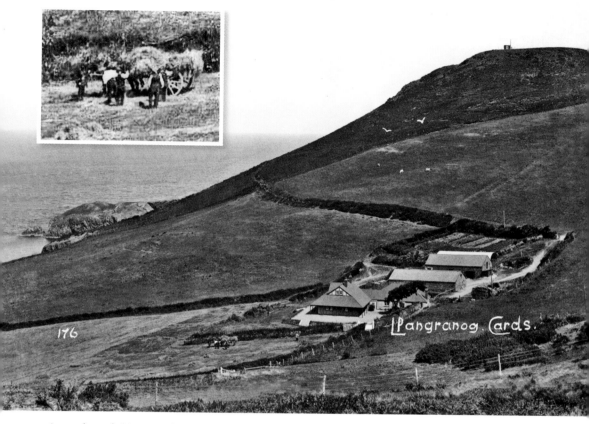

Apart from fishing, producing culm and some shipbuilding, Llangranog relied on its farms. Just below the buildings in the photograph above, there is a harvesting scene, which has been cropped and magnified in the inset.

I believe that Harry took this photograph sometime in the 1930s. What is interesting is that this looks like the site of the first permanent Urdd centre, or Gwersyll Urdd Llangranog, before it was developed into its current extensive complex. The Gwersyll was set up by Sir Ifan ab Owen Edwards on the land occupied by Cefn Cwrt Farm in 1932. A Mr Howell had donated the land.

The Gwersyll has developed over time into a wonderful facility, and is thought to be one of the best residential educational centres in Europe. About 35,000 children and adults benefit from language and education courses, together with experiences of adventure and fun, each year. Visit their website to see what it has to offer (http://www.urdd.org/en/llangrannog/home).

Llechryd & Manordeifi

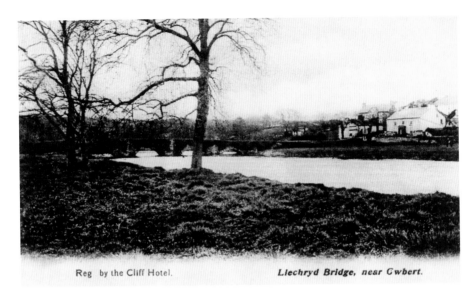

Reg by the Cliff Hotel. *Llechryd Bridge, near Gwbert.*

The name Llechryd translates into English as 'slate ford' and relates to a slate quarry that operated in the village in the 1700s. It was situated across the river from the Castell Malgwyn Tinplate Works, which operated from *c.* 1771 for around thirty years. It was reputed to be the second largest in Britain and during this time the look of the land changed. A canal was excavated to get fresh water to the works and a new road and two new bridges were built. A hundred years later, around 1910, Harry took the photograph above of the only remaining Castle Malgwyn Bridge. The photograph below shows the other side of the bridge. The site of the tinplate works was up the river to the left of Harry's position when taking this photograph.

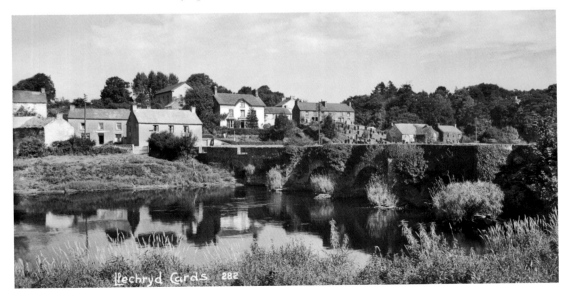

Llechryd Cards 282

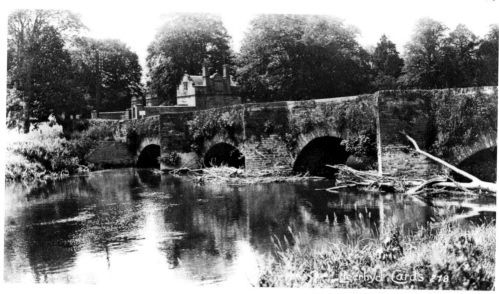

Prior to around 1840, the River Teifi was still navigable and tidal as far up as Llechryd. It was around this time that the slate quarry downstream in Cilgerran had dropped large amounts of slate into the river, making it so shallow that only crafts like coracles or canoes could safely navigate through the gorge. This resulted in flooding upstream in Llechryd, which is still a problem at times, as was the case in Harry's time. His photograph below shows the result. The bridge is at the end of the wall on the left and underwater. Coracles are the best thing to use when the river breaks its banks and the road disappears. At the time of writing (2014), we are experiencing extraordinarily strong gales and what seems like unending rain resulting in unprecedented floods. I wonder how wet Harry got when he took this photograph?

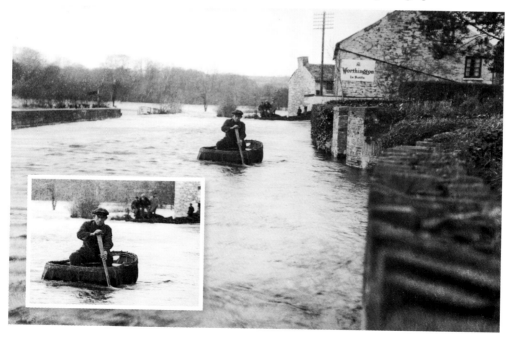

Across the river from Llechryd is Manordeifi church. I have included this postcard, although the church is in Pembrokeshire as it served the community of Llechryd. There has been a church there since the sixth or seventh century, but this one was built in the thirteenth or fourteenth century. It's now looked after by the Friends of Friendless Churches, who have held a 999 year lease since 2000. The inside is very old and has seating in box pews like the one in Harry's photograph (*below*). The ones on the eastern side have fireplaces like this one to warm the members of the congregation. On our last visit, the coracle was still there, resting against the wall in the porch for times when the river flooded and members of the congregation were stranded on the wrong side of the Teifi.

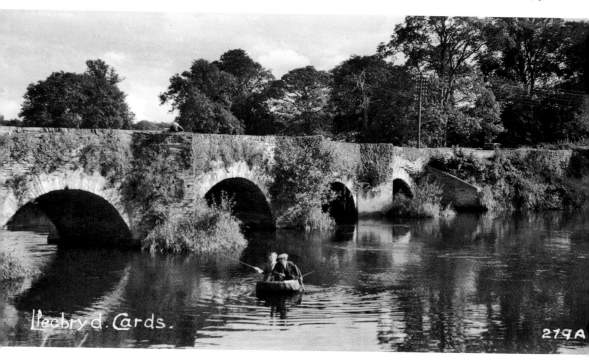

Llechryd is the place to have your own gwrwgl (coracle) made. All you need to do is contact Mr Peter Davies (http://www.coracle-craftsman.com). The gwrwgl is a wonderful craft, weighing about 15 kg, which is light compared with other boats, easily portable, and manoeuvrable on the water. You can fish using a rod, like my Uncle Arthur and the gentleman in the postcard above, or lay eel traps. However, it is difficult to get a coracle (net) fishing license. They are issued by the local water authorities and are expensive: £250 per season on the Teifi (at time of writing) and limited to twelve per year.

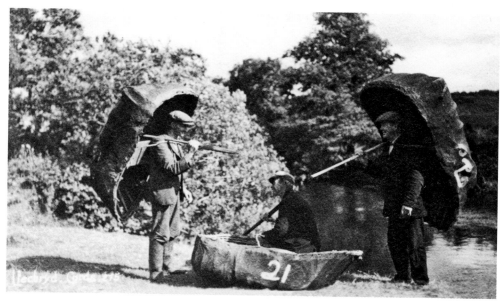

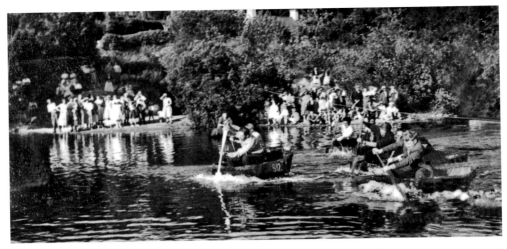

Before the 1930s, the coracle fishermen's licenses lasted for their lifetime and were passed down to their sons. This stopped and now this ancient tradition is kept going by a few diehard fishermen, who trawl the Teifi for salmon, sea trout and eels. It is no longer a means of earning a living, as was the case in the past when most people who lived along the river had their own coracle propped up outside their cottage.

Fishing was often done in pairs at night, with a long net between the two boats. The pair drifted downstream, controlling the coracle with one hand and holding the net in the other. Sometimes, someone working a single coracle would peg the end of the net to a bank and paddle round in a circle to catch fish. When a fish was felt struggling in the net, it would quickly be dragged into the coracle and killed using a wooden club or 'priest'. This had to be done quickly – a large salmon thrashing about could easily upset the coracle. At the end of the fishing run, the boats and net were removed from the water and carried back up the river for another run.

Above is a different experience – the coracle races at the Cilgerran Regatta, held in August of each year. The winner has just crossed the finish line.

Views along the River Teifi are worth seeing. The coracle is a very pleasant and gentle way to travel along the river. If you're not confident in a coracle, how about a canoe?

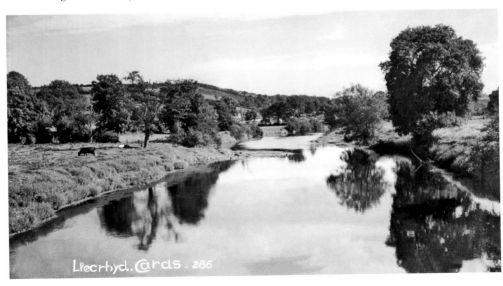

Llecrhyd. Cards. 286

Mwnt

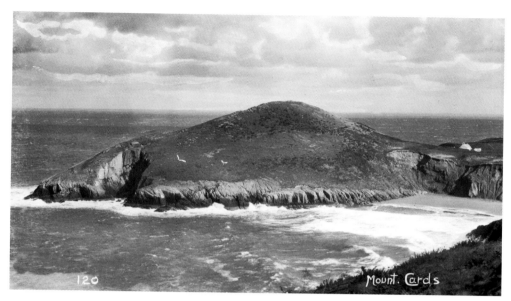

Mwnt is such a pretty little cove, with the church of the Holy Cross (Eglwys y Grog) sheltered by the hill that projects out into the sea. The cone-shaped hill called Foel y Mwnt gives the place its name. The church is thought to date back to the fourteenth century. Mwnt was used in the time of the saints by pilgrims on their way to Bardsey Island or St David's. This was during the sixth century, so there may have been some sort of church here then. Surprisingly, Harry has used the Anglicised name (Mount) for his postcards of Mwnt. He was normally keen to avoid this, preferring to use the Welsh place names.

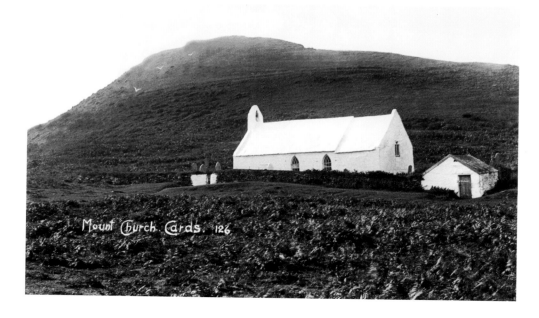

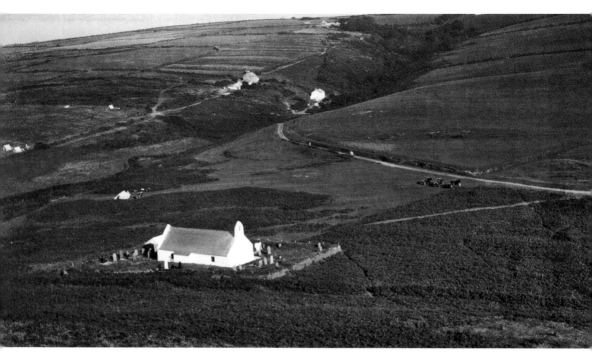

Back in 1155, Mwnt was the scene of violence when the Flemish tried to invade the country. It wasn't an enormous invading force and was unsuccessful. The locals celebrated their success with an annual re-enactment on the first Sunday in January every year up until the eighteenth century. It was called Sul Coch y Mwnt (The Bloody Sunday of the Mound). Why on earth did they stop? My dad told me that Harry had heard that bones of the people killed then were sometimes found on the beach after a storm.

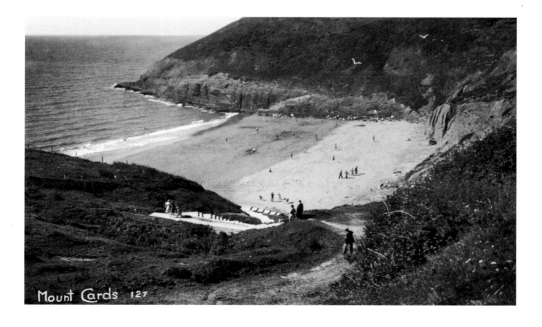

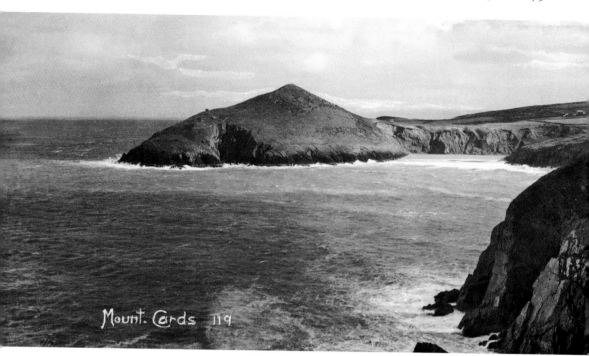

Last year, I slowly followed my husband climbing up the 250 feet to the top of Foel y Mwnt and scrambled down the other side overlooking the sea. There, an amazing sight greeted us. There was a family of dolphins fishing and playing in the sun. That provided an hour of total entertainment, especially as they were so close to shore and stayed there so long. Not only could we see them – we could also hear them. Despite its history, the beach is still popular and beautiful. It was included in the *Daily Mail*'s list of 'Europe's top ten loveliest hidden beaches'.

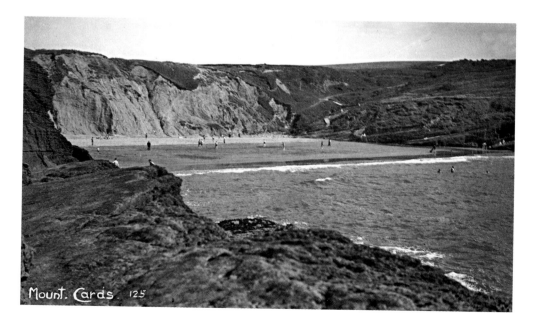

Newcastle Emlyn

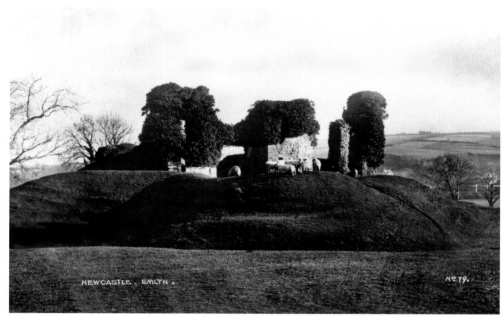

Sadly, very few of the photographs taken by Harry in Newcastle Emlyn remain. This selection provides a little glimpse into the town all those years ago. The ground around the castle looks well manicured, with sheep used to keep the grass down. The other photographs are of the 1935 Jubilee celebrations with the carnival king, queen, their attendants and the official-looking gentleman (*inset*). He appears to have been involved with organising some aspect of the celebrations.

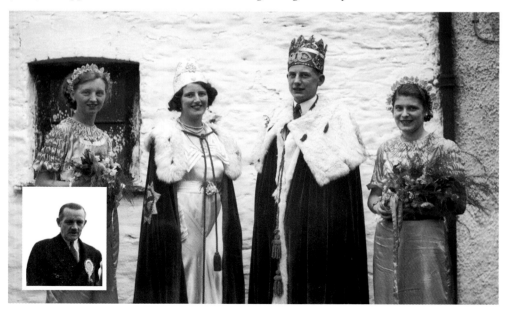

Penbryn

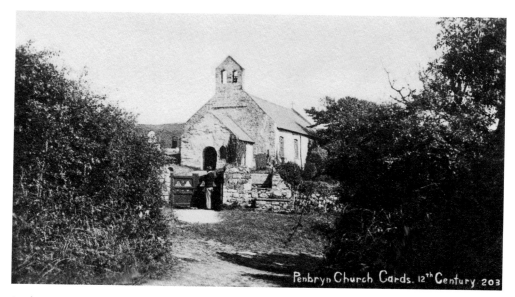

Penbryn means 'the head of the hill', where the church has been since the 1100s. It was dedicated to St Michael and is sometimes called Llanfihangel Pen y Bryn. The photograph of the church above was taken in the early 1930s as the man by the gate is my dad, who was in his early twenties and home on leave from sea. The beach is down the hill from the church. You drive down as far as Llanborth Farm, where you can park and have a cup of tea or coffee (in the summertime) before walking the 400 metres down the path to the beach, which is a mile long and quite beautiful.

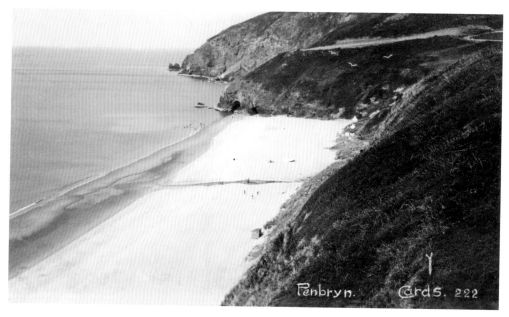

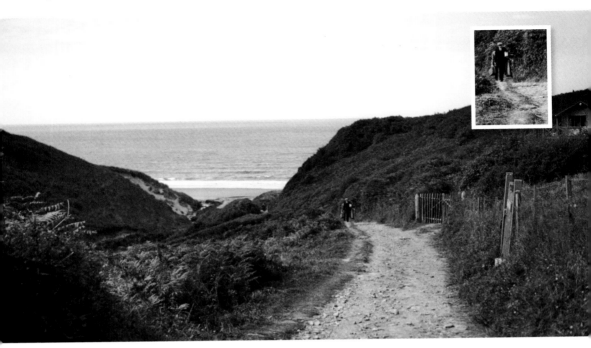

The lane to the beach is paved now. I wonder who the people coming up from the beach are – fishermen, perhaps, or could it be the minister and curate? They have obviously arrived by boat and don't appear to be dressed as fishermen would have been. There is an alternative route to the beach from the car park that runs alongside the River Hoffnant and through the woods.

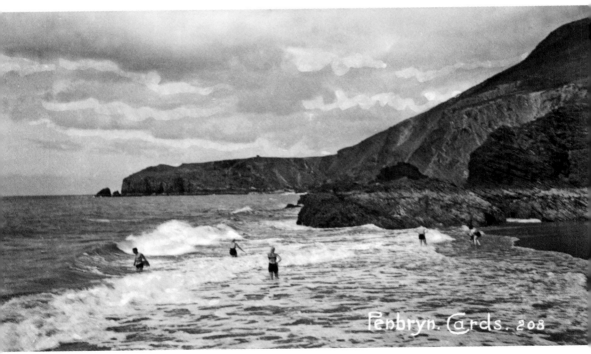

Penbryn. Cards. 208

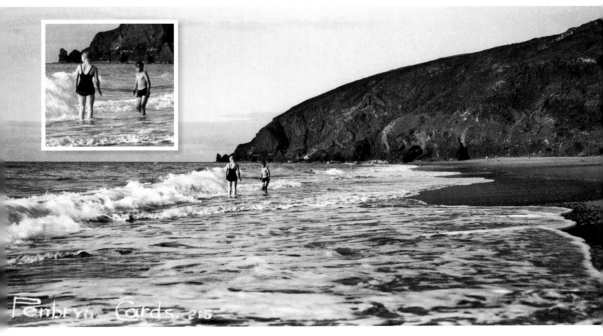

The beach at Penbryn was, according to my dad, always worth the time and effort to get to. It was so long and clean and was, in his day, a great place to camp in the summer. If you didn't have a car, which was the case when he was small, but did have a boat, then that was the way to get there. Above is my dad and my grandma enjoying the waves around 1920, although I'm not sure if 'enjoying' is the right word to use. Dad's expression suggests that it's cold. I can imagine him shouting, 'Hurry up, Dad, I'm freezing!' The National Trust cares for the area now and ensures that the beach remains unspoilt with no commercial development at all. In the 1700s, the beach was quite a busy route for delivery of smuggled goods, as indicated by the name of the valley: Cwm Lladron (Robber's Valley). Wine, tobacco and spirits came this way from Ireland and France to avoid paying taxes.

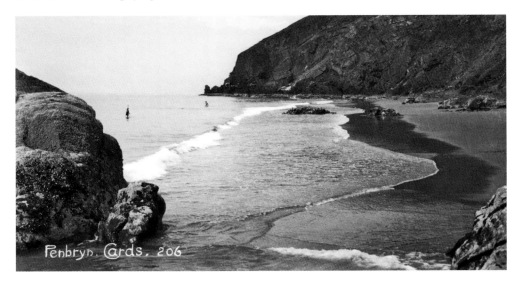

River Teifi to the Sea

In the section on Henllan, you saw the upper part of the river as it runs along the border of Cardiganshire past Newcastle Emlyn, Llechryd, Cenarth and Cardigan. These photographs give you views as it runs out through the estuary into the sea.

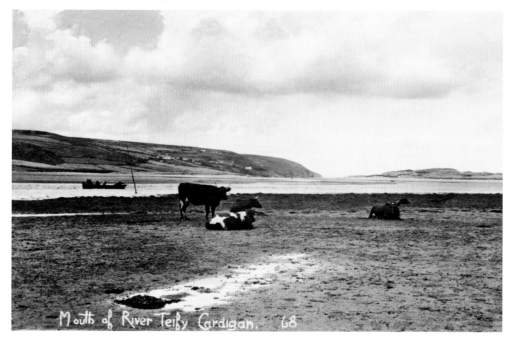

Mouth of River Teify Cardigan. 68

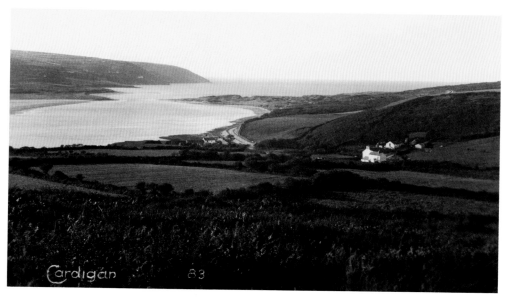

These are two of Harry's early photographs. The one above provides a good view of the Teifi estuary. The one below was obviously taken before fishermen had engines to propel their boats. If there was wind, then a sail worked, otherwise it was a matter of getting the oars out to row all the way up the river to get home to Llandudoch (St Dogmaels). Look closely and, to the left in the shallow water that is coming in over the 'bar' (sand bar), you will just see the lower half of two fishermen in the dusk. They were holding one end of a seine net as the men in the boat let it out as they moved across the river to circle around and join the other two. They would then have hurried to pull the net in before the tide rushed in over the sand bar – quite a risky business.

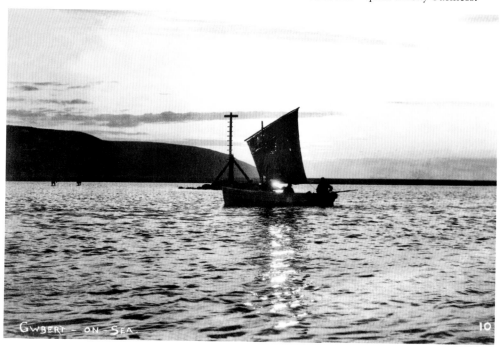

Tresaith

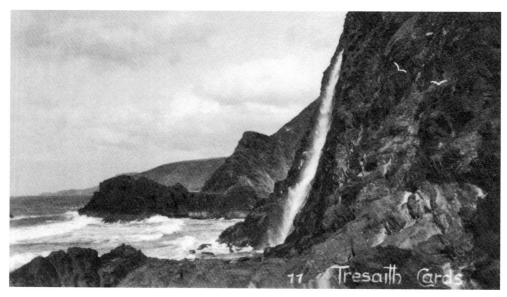

It is possible to walk from Penbryn to Tresaith, but you need to check the tidal times to be sure you don't get caught. Tresaith is such a lovely little cove with a most unusual feature: a waterfall called Ffrwd y Felin (The Mill Stream) that is fed by the River Saith (Seven), which rushes over the top of the cliffs and falls dramatically onto the beach. Historically, there were only two buildings in Tresaith before the mid-1800s: the Ship Inn and a thatched cottage.

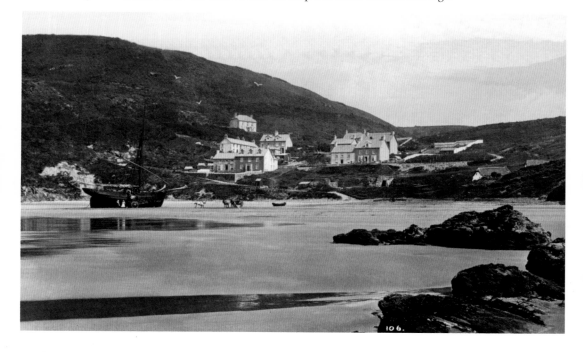

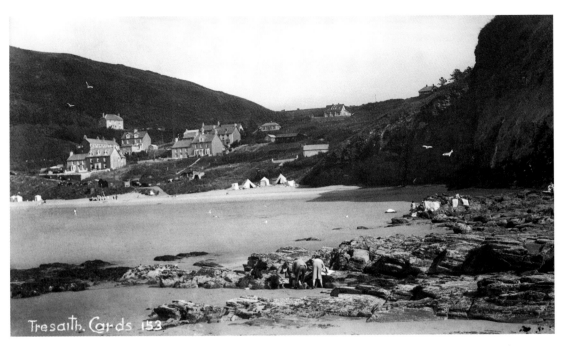

I believe the area in the postcard was the chosen site for the sea scouts to camp out. Back in Harry's day, Tresaith became a popular holiday resort. It's still a place people enjoy, especially in the summertime.

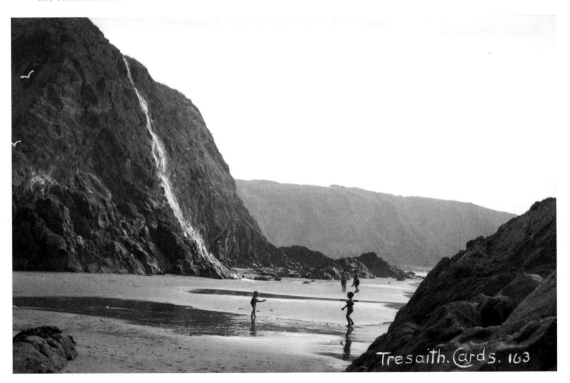

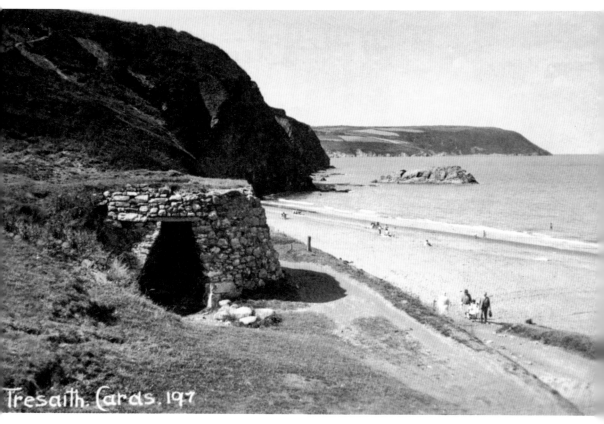

The house in this postcard was owned by Ann Adaliza Evans, an author who wrote under the *nom de plume* of Allen Raine. She wrote many novels between 1894 and 1908, when she died.

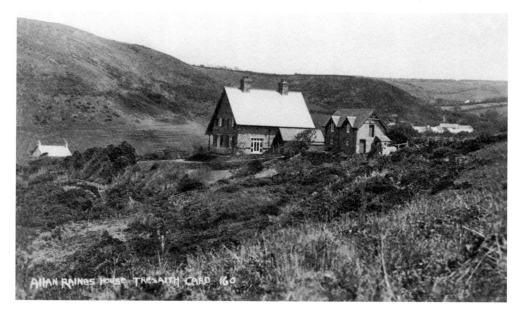

Cardiganshire Buildings

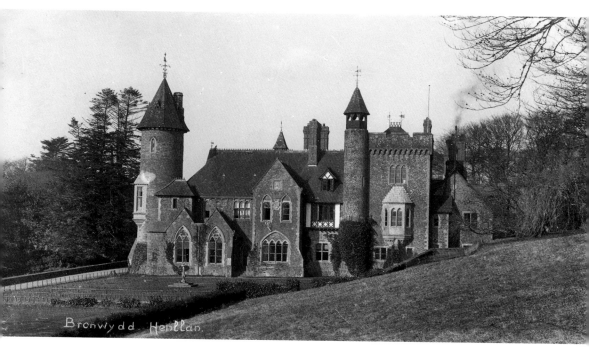

Bronwydd. Henllan.

Bronwydd, Henllan, Ceredigion

Bronwydd, also known as Bronwydd Castle, was built by Sir Thomas Lloyd in the 1850s by refashioning the previous seventeenth-century building (Cilrhiwe) on the site at enormous cost. He employed a Mr Penson to design a Gothic 'castle'. It was left to Sir Thomas' son, who found there were huge debts to be met. To avoid death duties, he gave it to his son, Arundel, who sadly was killed in the First World War. The property was sold in 1937, and the land was used for forestry work and the house as a Jewish boarding school. Slowly, the mansion that Harry thought was magnificent crumbled and now very little remains. Photographs of Bronwydd from the late 1990s show that the only part that remains almost complete is the right-hand square tower.

Llandygwydd Church

Unlike Manordeify church, Llandygwydd church no longer exists. I was interested to find some of Harry's photographs in J. T. Evans' book, *The Church Plate of Cardiganshire* (1914) and that one of these was of the chalice in Llandywydd church. The goldsmith's mark dated it back to 1573. The author suggested that it may have been the finest of three existing cups in the area from that time and was very well preserved. It appears that this may have been made after Edward VI (who was short of money at the time) ordered that plate owned by parish churches should be taken.

Plas Llangoedmore

Plas Llangoedmore is a grand house with a history dating back to the mid-sixteenth century, when it was designed by Edward Haycock of Shrewsbury for Rhys Lloyd. The property remained in the family until the late 1600s, when it fell into the hands of the Loyds of Ystrad Teilo through a marriage arrangement until 1728. It changed hands until 1797, when it was bought by Archdeacon Millingchamp, who was born in Cardigan in 1756. He was the son of Anne Gambold and Benjamin Millingchamp, who lived in the town. He studied at Merton College in Oxford and was ordained in 1777. Soon after, he joined the Navy as a chaplain and then became chaplain in Madras, where he spent almost twenty years. During that time he learned Persian and started collecting manuscripts, writing about the scenes and places he saw. When he returned home in 1797 he was wealthy enough to buy Plas Llangoedmore. The house stayed in the family until 1924, when it was sold, and I believe this photograph was taken as one of a batch for the sale. At the time of writing, a Google search shows that it is on the market for sale again.

Llangranog (Mrs Lowe)

Harry was asked to photograph not only mansions but homes loved by their owners. This photograph forms part of a set of six commissioned by a Mrs Lowe. All of the photographs in the set showed the house from different vantage points. They may have been commissioned to advertise it for sale, or to show relatives who lived far away what her new home looked like.

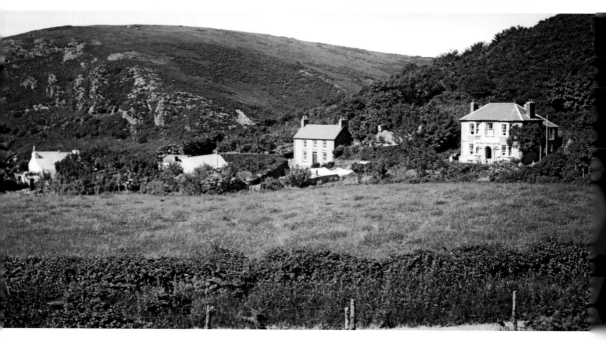

Penrallt Hotel, Aberporth

Harry usually took at least twelve shots of the buildings he was commissioned to photograph. Some wallets included as many as fifteen negatives or glass plates depending upon the customer's requirements. Three of this set are included. The lovely landscape view was obviously important to the owner, as it was to me. Penrallt Hotel is where my wedding reception was held and I thought Harry would have approved of the connection between his photographs and his granddaughter's special celebration. Finding these particular photographs brought back great memories of a wonderful day in such a beautiful place. It was a sunny day so the view out over the bay was particularly lovely. Harry would have been commissioned to take these photographs to be used by the hotel for advertisement purposes.

The 'Mystery Mansion'
I found this photograph among Harry's collection of houses he photographed – this was a great many, as he was concerned about the way that some houses had been left to go to ruin. I've tried to find out where this one is, and what it's called, without success. Can anyone help me? I do hope that it's still around and is now someone's home.

ACKNOWLEDGEMENTS

I would like to thank: Cyril Burton for sharing his historical memories with me and lending me his collection of books, glass plates and photographs; Peter Davis, author and dedicated postcard collector, for generously sharing his time, support and vast knowledge of the past photographic world of postcards related to my grandfather; Glen Johnson, historian and author, for sharing his knowledge of our local history, how it related to my grandfather's work and also for encouraging me to produce this book; Rob Squibbs, my cousin, for becoming part of this book by lending me our grandfather's plates and negatives; Paul Thirell, University of West of England, for suggestions about photographic processes.

REFERENCES

Cilgerran Language and Heritage Committee, *Cymuned Cilgerran mewn Lluniau/ Cilgerran Community in Photographs* (2007)

Davies, D., 'Those were the Days', *Tivyside Advertiser* (1984)

Davies, D. T., *Mainly Cenarth* (2010)

Davies, P., 'Harold Squibbs of Cardigan' in *Picture Postcard Monthly* (April 2005)

Evans, J. T., *The Church Plate of Cardiganshire* (1914)

Gernsheim, H., and A. Gernsheim, *A Concise History of Photography* (1986)

Green, E. T., and D. Davies, *Cardiganshire Antiquarian Society. Transactions and Archaeological Record* Vol. 2 No. 1 (1915)

Lewis, S., *A Topographical Dictionary of Wales* (1833)

Lynn-Thomas, Sir J., 'Key of All Wales' in *South-west Cardiganshire Modern Art* (1932)

Mulligan, T. (ed.), D. Wooters (ed.), *A History of Photography: From 1839 to the Present* (The George Eastman House Collection) (2005)

Newhall, Beaumont, *The History of Photography: From 1839 to the Present* (1982)

WEBSITE REFERENCES

Cardigan Golf (http://cardigangolf.com/history/)
Ceredigion County Council (http://www.ceredigion.gov.uk)
Encyclopedia Britannica (http://www.britannica.com/)
Friends of Friendless Churches (http://www.friendsoffriendlesschurches.org.uk/)
Glen Johnson (http://www.glen-johnson.co.uk/)
Georgian Property (http://www.georgian-property.com/)
Henllan Walks (www.ceredigion.gov.uk/index.cfm?articleid=12137)
Not So Official Newport Pembs Site (http://www.newportpembs.co.uk/)
Welsh Biography Online (http://wbo.llgc.org.uk/)
Wikipedia

IMAGE CREDITS

Abraham Squibbs: Fig. 1.
Author: Fig. 11 and sketch of fishing smack (*page 27*).
Bridgwater Carnival: Fig. 15.
Vivian Squibbs: Back cover portrait.